1984

THE NEW LITHOGRAPHY

MEL HUNTER

THE NEW LITHOGRAPHY

A COMPLETE GUIDE FOR ARTISTS AND
PRINTERS IN THE USE OF MODERN
TRANSLUCENT MATERIALS FOR THE
CREATION OF HAND-DRAWN ORIGINAL
FINE-ART LITHOGRAPHIC PRINTS

VNR VAN NOSTRAND REINHOLD COMPANY
NEW YORK CINCINNATI TORONTO LONDON MELBOURNE

Mylar and Kronar are the registered trade names of two film base products manufactured by the DuPont Chemical Co., some uses of which are described herein.

Copyright © 1984 by Van Nostrand Reinhold Company Inc.
Library of Congress Catalog Card Number 83-1196
ISBN 0-442-26222-1

Printed in the United States of America
Designed by Gilda Hannah

Published by Van Nostrand Reinhold Company Inc.
135 West 50th Street
New York, New York 10020

Van Nostrand Reinhold Company Limited
Molly Millars Lane
Wokingham, Berkshire RG11 2PY, England

Van Nostrand Reinhold
480 La Trobe Street
Melbourne, Victoria 3000, Australia

Macmillan of Canada
Division of Gage Publishing Limited
164 Commander Boulevard
Agincourt, Ontario M1S 3C7, Canada

16 15 14 13 12 11 10 9 8 7 6 5 4 3 2 1

Library of Congress Cataloging in Publication Data

Hunter, Mel, 1927-
 The new lithography.

 Includes index.
 1. Chromolithography—Technique. I. Title.
NE2515.H86 1983 764'.2 83-1196
ISBN 0-442-26222-1

In memory of Stow Wengenroth (1906–1978), the premier American artist/printmaker of this century. For almost fifty years, he worked steadily at the creation of hundreds of beautiful, sensitively drawn, small masterpieces of black-and-white stone lithography. All, except for two, were taken to the shop of George C. Miller and later to his son, Burr Miller, for impeccable hand printing. They worked steadily together during all those many decades when fine-art lithography was virtually forgotten as an art medium in the United States.

I fell in love with Stow's work from the first day I saw it, and resolved to follow in his footsteps as a maker of fine-art lithography. There have been many, many times when I have found renewed determination by remembering his ability to keep working at his own inner-directed pace and true to his own private vision, when far lesser talents ran after the spotlights.

The handsome book of his collected works, *The Lithographs of Stow Wengenroth*, by Ronald and Joan Stuckey (published by The Boston Public Library in cooperation with Barre Publishers), is far and away the most well-thumbed book on my art shelves, for reasons obvious to anyone who has gone through it. I thought then as now that no other book of an artist's life's work so perfectly documented the steady evolution of skill and aesthetic judgment throughout a long and fruitful career.

The Superstars of the art world won't know or care whom I am talking about, and none of its promoters ever ran to him with a bucket of money. Perhaps that's just as well.

CONTENTS

FOREWORD

By 1981, it became clear that the time was approaching when the Mylar method of making original color lithographs was maturing sufficiently to offer the basis for an explanatory book answering the constant flow of questions which were coming to me from other artists, students and printers, both fine art and commercial.

I decided to do this book, but only if it could be produced from the artist's point of view rather than that of the printer. There is a generous shelf of books on traditional stone lithography, and all view the subject from the point of view of the printer. They are uniformly, from the artist's point of view: BORING. They say very little that a working artist can interpret in his own creative terms, but an awful lot that sounds technically formidable. As a result, there are remarkably few artists, out of the national art population, who ever even consider making a lithograph in black and white, let alone one in full color, where the medium really comes alive.

Many oil painters, watercolorists, and pencil drawers produce books by themselves as artists for artists, and couched in that unmistakable slant of mind that other artists can translate effectively. That is what I hope this book will do, at least in one sense. This book is not about my art, i.e., how I build a landscape in perspective, how I define the features of a subject's face, and so on. But it is a personal statement about how I use the tools of Mylar lithography to do those things, and then how the resulting art is processed to produce the final result beautifully.

At this time, there is probably no one else with the necessary combination of more than a decade of constant technical research, concentrated full-time making of major color print editions with their subsequent testing in the marketplace, and constant hands-on experience with the techniques whereby Mylar art is plated, inked, and passed through the press. Certainly scores of others are accumulating a body of experience in one aspect or another of these dovetailing parts of the printmaking process, but very, very few in all three. Michael Knigin at Pratt Institute is the only one who comes to mind, and I believe he may have graciously stood back. Perhaps he will publish also in time. I hope so, for his approach would be different in some respects from mine, and would be complementary to it.

It may seem anomalous that a book about color printing should be produced with not a single color illustration of examples of the finished work. But, this is a journeyman's book aimed at artists, printers of art, and advanced students of art who all live the use of color every day of their lives. If any reader cannot mentally accept or colorfully imagine the powerful or subtle, but always luminous color which galvanizes the few actual prints chosen as examples, and shown in black and white, then that reader's own capacity to create *color* lithography from his or her own black and white drawings needs further development which only thought and practice can provide. But that is why I chose Paul Callé's magnificent *The Mountain Men*, a one-color print, and my own

The Woodsman as two of the very few examples I had room to display. They can speak volumes to any artist about what can be done with only one color, with ordinary artist's drawing tools, in his own studio.

The publisher and I have set out to produce a very inexpensive, easily disseminated magic key to a whole new way for any artist to spread his or her best original works much more widely, and also to produce a clear and concise handbook to enable schools which teach printmaking to give their students a skill in printmaking that would actually equip them to make a living with it once they graduate. That is certainly not the case up to now, except for a microscopic fraction of such students. The reason isn't the fault of the schools, but the fault of the medium's capacity to produce art of relevance to a large enough public to support it. Mylar-method lithography can and does reach such a public.

I must extend my sincere appreciation to the many fine artists, printers and all others who have helped me put this book together. These include especially Burr Miller, proprietor of George C. Miller & Sons of New York for the lovely printing, under his own hands, of nine of my editions drawn in grease on stones and plates back in the days before Mylar swept me up with its breathtaking potential, and six of my best editions drawn on Mylar after I made the irrevocable decision to convert to the new technique with my heart in my mouth.

And there is Mauro Giuffreda, Technical Director and Master Printer of the American Atelier in New York, who came to Grafton, Vermont, when I was first establishing my own hand-print research workshop, Atelier North Star. Mauro made countless useful suggestions on shop layout, equipment, and supplies that work and those that don't and in fact, came again to proof by hand on my Brand press one of the very early color images I was trying to get to work on the hand press. There was a lot nobody knew in those days, and his steady experience in plate hand printing was most useful to me. We have freely and frequently exchanged technical experiences and assistance in problem solving—seemingly the sole activity of creative printmakers.

From the days at the Bank Street Atelier, where he himself proofed my first lithograph, *January Thaw* in 1971, Mauro and the fine crew of printer-craftsmen he directs have printed scores of my main editions in the last decade. Of that group, I especially wish to credit and extend my thanks to M. Paul Valette and M. Michel Tabard, who operated the lovely old Marinoni-Voisin flatbed direct press on which much good work was done.

Manuel Ricalde, known everywhere as "Manny," was for years the head of offset printing at the American Atelier. He printed many of my best offset pieces there. I was so impressed with his love and skill for innovative printing that I asked him to come and be the first to turn the beautiful Heidelberg press in a new print facility in Fairfield, Connecticut where, for a time, some of the most handsome and innovative printing ever seen in these parts flowed from that press. Manny has an intuitive ability to develop simplified ways to make things work better than they ever have before. Much of the elimination of complexities in handling positive plates with seemingly impossible-to-print imagery on them, and the modifications to inks with which to take best advantage of them are the result of his thinking. He *thinks*. For all those things, I thank him most sincerely.

The Windham Foundation, owner of the premises in which my wife, Nancy, and I have operated our beautiful retail gallery, Gallery North Star, for eight years, and in which my print shop, Atelier North Star, is also located, has provided many, many tangible assistances without which I could not have pursued the steady trail that led to the developments this book describes. To them I wish to make clear my heartfelt gratitude.

And especially, I want my wife, Nancy, and my daughter, Amy, to know, each time they see this book in future years, that though all three of us have had to sacrifice many comforts, many vaca-

tions large and small, many Sundays together, it hasn't come to naught. Far from it. I hope they both will take pride in it always, for they both made sacrifices of which I have always been conscious and deeply grateful.

All the photographs which show the work in progress in my shop were shot by Fletcher Manley of East Norwalk, Connecticut, a fine photographer who also understands the intricacies of color printing, and who has always unstintingly done whatever I needed when I needed it. He twice made four hundred mile round trips to shoot the work for this book, giving up weekend time with apparent pleasure. Where does one find such people, now.

Finally, I wish to express my pleasure that the following important artist/printmakers permitted examples of their Mylar prints to be shown as examples of the quality of image and varieties of style the Mylar method encourages in color lithography:

Paul Callé
Merv Corning
Michael Knigin
Raphael Soyer
Jamie Wyeth

INTRODUCTION

The fine-art printing technique known as lithography, based generally on the mutual reluctance of water and grease-based inks to invade any area on a printing surface already occupied by the other, has been available to artists for nearly two hundred years. But practiced as it was on heavy lithographic stones and balky zinc plates, it remained a cumbersome and demanding art form and understandably went into virtual eclipse in both Europe and the United States during this century.

Then, in 1960, a determined and persuasive American artist-cum-entrepreneur named June Wayne decided this atrophy of a fine old art form must be reversed. She foresaw the enormous power building in the art marketplace around the newly emerging American style known as Abstract Expressionism. Having had extensive experience in lithographic printmaking in Europe, she correctly reasoned that this lost art could become a most useful, almost perfect, medium for artists wishing to express themselves abstractly on the working surface. In the process, they would be producing multiple images for a wider art public, generated by an unprecedented prosperity and buying power and by a much broader public education in the amenities of life.

June Wayne thereupon founded the Tamarind Lithography Workshop in Los Angeles. From the outset, the persuasiveness of this extraordinary artist ensured that Tamarind's future would be underpinned by a series of ongoing grants from the Ford Foundation, which eventually totaled millions of dollars. With a small staff, the new organization undertook a long-term research-and-development effort to reconstruct the old, forgotten skills of the great European lithographic craftsmen of the past. To existing knowledge they hoped to add a very considerable body of new techniques which would be especially suitable for producing the constantly experimental, restless work of the Expressionistic artists who dominated the art world at the time.

The result was an assemblage of massive money for research, massive support for the constant flow of artists coming to Tamarind to make prints free of the usual constraints of self-support, and a whole new national apparatus for the discussion of, dissemination of, and collection of American art, especially that of the suddenly dominant Abstract Expressionist style. All this resuscitated traditional stone lithography in the eyes of the art "scene," and in just one decade rebuilt it into a major art medium.

Many important artists, printers, and academic enclaves made complementary contributions to this expansive rebirth of an old art form. But it was Tamarind that certainly plowed the ground, sowed the seed, and spread the fertilizer in the national network of museum print curators, art programs at major schools, and the intellectual sections of the art press.

Still, by the 1960s, there was a number of very important ateliers in the East; together they combined formidable skills and rendered great impact on the world of printmaking.

One of these ateliers was unique. During the long eclipse of traditional stone lithography as a major art form in the United States, the brightest of the very few shining lights was the shop of George C.

Miller & Sons of New York. George Miller managed to keep his small shop in continual operation from 1918 into the 1950s, when he retired and invested his son, Burr Miller, as Master Printer. The firm continues to this day under the same name with Burr Miller's two sons, Steven and Terry, working with him at the presses.

Scarcely an artist in this country of any renown failed, at one time or another, to make superbly printed stone lithography in this seminal shop. As a result, in 1976 the National Collection of Fine Arts of the Smithsonian Museum in Washington, D.C., mounted a beautiful and unprecedented retrospective exhibit of the shop's historic work.

George C. Miller & Sons has been steadily producing Mylar-method editions for a number of years, using a platemaking rig of simple, inexpensive design directly adapted from my own. Burr Miller contributed a personal statement to the text of *The Mylar Manifesto: The New Lithography*, published by my own printmaking-research workshop, Atelier North Star, in 1979.

In 1967, another very important event in American lithographic history took place with the founding of the Atelier Mourlot in a wonderful old building on Bank Street, in New York. This offshoot of the famous doyen of all Parisian print ateliers was staffed by, among others, M. Michel Tabard and M. Paul Valette, two classically trained French printer-craftsmen who had printed for many of the most famous French artists of the century before coming to the United States.

Atelier Mourlot went through numerous changes of ownership, becoming the famous Bank Street Atelier, then the Shorewood Atelier, and finally moving uptown to become the American Atelier. But its unique staff remained always intact, working constantly with the steady stream of better-known artists from all over the world who wanted to print the best traditional lithographs with this superb crew, and to sell their work in the United States.

For years, I had been a regular visiting artist, bringing my own steady flow of stones and plates. After more than fifty editions, often in many colors,

I felt completely at home there, and trusted the expert handling my work received. Therefore, in 1975 I entered into discussions with Robert Summers, director of operations, as to the possibility of using Mylar techniques for full multicolor editioning. I brought in a thick, heavy roll consisting of several hundred Mylar drawings, part of the more than eight hundred such drawings and test images I had made since 1970 using many different drawing tools and pigments on a number of different transparent and translucent surfaces.

He looked these over and read through the text of my October 1972 article in *Book Production Industry* on the specialized use of these techniques for preseparated book art. I told him I was sure that plating techniques for such work were sufficiently reliable, and that the drawing techniques were now sufficiently mature for an all-out effort at full multicolor printing every bit as ambitious as I would attempt with stones and plates.

Robert Summers is a man of infectious enthusiasm for good art and new ideas. He made a commitment of all the shop's resources necessary to measure Mylar-edition quality against that of traditional methods. My part of the bargain consisted of committing a series of color editions, for which I had a supportive publisher happy to accept any printing stipulations I cared to specify. We went to work in earnest.

The American Atelier's Technical Director and Master Printer, Mauro Giuffreda, is an expert traditional stone print craftsman, with an extensive background and academic credentials in the traditional technology. He threw himself and all the shop's facilities into the project. Working closely together, during the last months of 1975, we succeeded in testing and plating a whole series of color drawings for my editions #55, 56, 57, and 58, all of which were completed and published within a few months, in early 1976.

From that moment on there ensued an extraordinary alteration in the whole flow of work through the American Atelier. The overwhelming majority of artists arriving from all over the world, upon being shown Mylar work in progress and being offered a

free choice of working methods and materials, passed the stone shelves by to choose Mylar and its derivatives. That proportion holds to this day.

Thousands and thousands of editions have since been drawn, washed, painted, sprayed, rubbed, spattered, palette-knifed (yes, palette-knifed), and otherwise put down on these translucent sheets by every style of art maker imaginable, famous and yet-to-be-famous.

Michel Tabard and Paul Valette, at first so dubious of these revolutionary changes, soon went vacationing home to Paris, full of extraordinary tales to tell their printer friends in the old French shops. They have been very proud of many lovely images pulled from their presses from the *plastique*. And Mauro Giuffreda, having contributed a great deal to the Mylar method's successful adaptation to mainstream lithography, also contributed a personal statement to *The Mylar Manifesto*.

Many professional artists who now make regular use of the Mylar techniques described in this book are experienced in traditional printing methods. Many other important professional artists have been enticed to undertake serious lithographic projects for the first time upon being exposed to the relatively simple, straightforward techniques and tools needed to do the work. Most do the creative work in their own studios, using familiar drawing tools, thus greatly cutting down the cost, and bring a whole sheaf of colors-to-be into the atelier in a roll under one arm. Anyone who has tried to manhandle a four-hundred-pound rock while drawing a single color image will see why this difference is immediately interesting to the artist.

These professionals have found they can concentrate on the aesthetic development of their art and concern themselves much less with whether the problems of printing will dominate and thus determine just how freely they can create on the drawing surface. This same freedom holds true for students doing lithographic images for the first time. There is no less need for the artist to learn and understand color values and densities, color overlaying, tonality, grain, and texture, but essentially, what he puts down on the drawing surface can be corrected at will until he is completely satisfied and can be relied upon to print successfully. Both the artist and his printer can easily and quickly learn the quite simple family of procedures for making the printing plates from the art.

This difference from traditional lithography is easy to state, but it represents a *profound* revolution in lithographic printmaking, converting it from a medium restricted in many ways by printer's problems to a medium responsive to the creative desires of the artist.

No artist is really comfortable creating by committee conference the art that will bear his or her signature. No artist is really very comfortable seeing his own precious stone image, perhaps a month's work, entirely washed away by a swipe of the printer's solvent rag during preparation for the press, and then later to see it recreated by the hand of the *printer*, as *he* makes judgmental rubbings-up with his grease-laden asphaltum rag or rollup ink roller.

It's often a shock to realize that unless a good photograph has been taken of the artist's actual grease-drawn image, no one can tell, except from memory, whether the new rolled-up image built up by whatever judgment and skill the *printer* possesses is actually more than an approximation of what the artist drew.

All that is absent in Mylar-method lithography. The artist's drawn image survives the plate preparations for the press absolutely unchanged and available for corrections or replating if necessary. And the plates are superbly predictable. The fickle and frustrating experiences of traditional stone lithography—which students have wryly personified as "The Great God Lithograph," a capricious entity known to flicker from smile to frown in the blink of an eye—no longer needs to be propitiated by sighs and twitches of anxiety as the artist's image approaches all those many steps in preparation for the press.

What a relief! And what beautiful work these new materials make possible.

One final matter of stage-setting needs to be ad-

dressed. Many references could be cited, dealing with both the question of the academic acceptability of Mylar-method prints and the use of the word "original" to describe any print. It is now widely agreed that if the artist himself made the art image used for the printing—if he and not some image-copying craftsman (chromist) drew it—then, whether or not a printer worked on the preparation of that image to ready it for the press, it is accepted as an "original print."

Most serious practitioners and scholars of contemporary printmaking have accepted and adapted to the culture shocks occasioned by the sudden appearance of a full-blown, mature printmaking process that seemed on its face to make obsolete almost all the painstaking reconstruction and amplification of classical lithographic techniques. That's what a lot of hasty commentators thought the Mylar method was.

But appearances are deceiving in art, as they are in all other endeavors worth making. Even a little experience with Mylar-method materials makes crystal clear that there is no less hard work involved, only less muscle. There is no less skill involved, only more chance of it showing. There is no less time involved in the artist's creative work, often a great deal more, as he feels the possibilities growing under his fingers. And there is certainly no less expense. All lithography is time- and expense-intensive. That is why it is so important that the result be worth the effort.

Ever since the day I produced my first full-color Mylar-method edition, I have been asked countless times to advise and assist others who wanted to make use of this new family of printmaking techniques. I have done this for at least a dozen printing establishments across the country, for firms that publish the editions of many famous artists, and for many artists themselves, professional, part-time, and student.

This book is intended to flesh out these efforts by giving a practical description of Mylar-method printmaking thorough enough to enable any competent artist or student to prepare eminently printable art, ready for plating and editioning by any of several different lithographic press methods. And, additionally, I am including all the information and technical guidelines necessary for any competent printer to effectively print that art, whether his press is hand or machine-powered, direct or offset, flat or rotary.

There are photographs of several tools, gadgets, and techniques explained in the text which were devised by me to solve certain problems as they occurred. I long ago decided not to restrict innovations I may have created in this field by any attempts to secure patents or licensing agreements. Anyone is free to use and improve them, in the interests of more and better printmaking for all of us who love the medium.

I wish you the best of good luck with whatever use you are able to make of the information in these pages. I know I have loved every minute of my twelve years of work with these intensely rewarding artmaking tools and techniques.

EQUIPPING

In reviewing the list of tools and materials which can be used in Mylar-method lithography, any artist who has made traditional stone lithographs will immediately notice that there is almost no commonality between the tools of the two methods. This dissimilarity will be in effect at every stage of the process until ink is actually rolled on the printed surface. Even at that final stage, there are important differences.

It is useful to remember that a competent artist can make a magnificent Mylar image, ready for plating, with just one of the pencils or liquid pigments listed below. If an artist is especially sure of the approach, there may not even be need for erasers or cleaning solutions. But what does hold true for both the stone technique and the Mylar process is the wide choice of drawing tools available to the artist working in each method.

MATERIALS

Stone grease pencils come in a series of numbered grades which define the hardness and the greasiness of the pigment mix. The black of the grease pencil is simply lampblack added to give the mix of greases and waxes visibility on the stone. The soft pencils contain more grease and less waxes and the harder pencils the reverse. If an artist intermixes work areas done with a #5 Korn pencil with areas done in #1, the drawn areas may superficially appear to be similar, but the unequal penetration of grease into the

stone's pores in the two areas will give the printer different etch preparation problems and will produce printed areas that greatly differ in richness and power of image.

In Mylar drawing, which is not based on grease penetration of the working surface, this difficult judgment about how much grease has penetrated down into the working surface is entirely absent. You get what you see. But, in one respect, the artist must still recognize that the drawing must be prepared, generally, to one scale of visual values from zero to 100 percent of color or tonal saturation; from the faintest fading-in of a vignetted tone edge up through the successively darker gray tones to solid black. The problem of judgment can best be absorbed by taking a 6H or harder pencil, a 2H, an HB, and a Stabilo #8046 and #8008 china marker, and making a one-inch square solid area with each, fully drawn over and over until the square is covered with all the pigment that pencil will put down. Next to each of these test patches draw a similarly sized square of fading-away tone, solid near the other square but fading out to zero at the other edge.

If these areas are viewed on a light box, it will be immediately clear that the 6H solid patch seems quite transparent, while the Stabilos seem stygian black. The 2H and HB patches fall in between, seeming somewhat less than totally black. The point to remember is that the plate made from the drawings can be burned by different procedures so that any one of these patches can represent a full 100 percent solid black area and the corresponding toned patch will vignette away just as drawn, but the plate cannot

be burned to hold the same relative values for all the others simultaneously.

Areas of drawing which are somewhat separated from each other can be burned to different scales by masking. This is a valuable technique, and its use greatly enlarges the range of techniques the Mylar artist rapidly develops.

To my mind, the most important value of the list of tools that follows is that the tools are almost all old friends, either the same as or similar to artist's materials used since most of us first picked up a pencil. It is for this reason that most of the creative work can be perfectly well done right in the artist's own studio, and need not be taken to the premises of the printer until ready for printing.

Here is a suggested kit for a really well-equipped Mylar-method artist:

pencil and stick drawing pigments
graphite drawing pencils—6B to 6H (I like Venus
 and Berol Turquoise best)
draftsman's graphite leads and holders—2B to 2H
 (I like Berol Turquoise best)
Stabilo china marker pencils #8008 and #8046
graphite sticks
Conté Crayons, black
flat lead carpenter's pencils

There is very little that cannot be executed linearly or tonally with these materials. There are probably fifty other grades, trade names, and specialized types of pencils on the market. I have tried everything I could find which makes a mark, and most others have some drawback when compared to the simplified family of pigments on my list. But by all means experiment. You will undoubtedly find ways to adapt other materials to suit your own needs. Products on the market do evolve, degrade, and improve all the time.

Grumbacher Speed-O-Paque or Kodak
Red Film Opaque

Both Speed-O-Paque and Kodak opaque have superb covering power for making opaque solid areas, brushing in totally opaque, in one coat as a rule.

Some containers of Speed-O-Paque will occasionally yield areas which will dry unevenly on the Mylar, leaving patches which look dark red and damp. In fact, they *are* damp, and will not dry at all. If you don't correct this before putting that surface in contact with another drawing or the plate, you will have trouble.

The problem can be immediately solved by rubbing the whole area down lightly with talc or talcum powder, rice starch, or corn starch. Blow away the excess, and the tacky surface has been permanently dried. I have not had this problem with the Kodak opaque, which comes in a glass bottle which does not allow solvents to diffuse out through the container wall as does the plastic bottle used for Speed-O-Paque. Many commercial printers, who all use opaques all the time, pour out a quantity into a shallow plate or cut-off bottom of a plastic container and allow it to dry. Then the opaque is easily readied by a wet brush, and the resulting opaqued areas always dry perfectly.

In the event that any of this material picks off on the surface of the plate under vacuum during the burn, be sure it is lightly washed away with clear water *before* the plate is developed. If this is done carefully, no trace will appear on the finished plate.

Pelikan Tusche or Tusche T Inks, Black

Tusche inks are much more satisfyingly opaque to light than most other drawing inks, especially India inks. There are other tusche-type inks on the market. All are good. They can be applied with brush, pen, or crowquill, ruling pen, toothbrush, airbrush, daubers, stamps, rollers, or any other applicator you experiment with. Tusche inks are waterproof when completely dry. Several of the solvents and cleaners described later will remove them.

Artist's Acrylic Color, Black

Artist's acrylic black paint is superdense and excellent for Mylar work. It can be applied in any consistency, directly out of the tube or as a thin wash, providing big, hard lumps are not left to dry. I have seen images made by a palette-knife artist, using only his knife and color from the tube, which plated and

printed with that unmistakable look so prized by knife-working artists. The artist who made two multicolor editions in this manner was thrilled with the results.

When fully dry, acrylic is completely waterproof. It can be removed with alcohol and patience.

Artist's Tube Gouache and Poster Color

Tube gouache and poster color paints are both useful as drawing materials in their own right, making various washes, sprays, and other tonal images. But they also have a special use as stopouts or friskets to block the adhering of other overapplied pigments in a controlled manner. Their effectiveness is based on their water solubility.

This technique is begun by applying poster color or gouache, preferably in a bright color which will contrast well with black, to all areas which are to be blocked from receiving the image pigment. These paints can be applied over large areas, or in very fine areas and hair-thin lines. This is an especially useful way to produce intricate multicolor work requiring close register and fine detail, such as twigs and leaves against the sky, or patterning in cloth, and so on. When the poster color or gouache is completely dry, the image pigment is applied right over it and the desired image area. If it is to be brushed on, care must be taken, since diluted acrylic contains water and will loosen the stop-out, as will water-based inks. It is especially useful to use the non-water-soluble artist's alkyd black described below. If it is to be sprayed on, all of the image liquids which dry waterproof can be used. Opaques, which dry water soluble, cannot be used.

When the overapplied image pigment is fully dry (a hair dryer or powerful lamp will greatly speed the process), the whole sheet can be held under a faucet and the frisketed areas lightly rubbed with a finger or pad. The underlying poster color will dissolve and wash away, taking the overapplied pigment with it perfectly. Of course, if other areas on the sheet are water soluble or pencil drawn, the frisketed area can be worked clean with patience, small sponges, Webril-wipe pads, paper towels, cotton swabs, and a little water without disturbing the other work nearby.

Artist's Oil Color or Alkyd Color, Black

Black oil color can be applied to Mylar in any way the artist desires, since the surface is impervious to the oils and solvents it contains. Beautiful oil washes can be laid down, the color diluted with a number of solvents from synthetic thinner to turps to Winsor & Newton Liquin. As a variant on this technique, Winsor & Newton alkyd black, which dries much faster, can be substituted with any of the same thinners, since alkyds and oils are intermixable and interchangeable. They differ only in that oils require days or even weeks to dry, whereas alkyds require an hour or two to be dry to the touch and overnight to be completely permanent.

Liquid Cleaners and Solvents

A number of liquid all-purpose cleaners and chemical solvents are useful to dissolve and remove unwanted pigments from image areas, to degrease the drawing surface by removing oily fingerprints and residual films and smudges left by other materials such as tapes or friskets, and to clean away dust and eraser smudges and fuzz.

Liquid Cleaners. All-purpose liquid cleaners like Fantastic or Formula 409 are most effective for routine cleaning of smudges, removal of pencil and ink drawing areas, and general cleaning of the drawing surface. They are not greasy and do not leave any objectionable film after use, especially with a final clear-water wiping. To clean small areas abutting or surrounded by image you wish to keep undisturbed, use a drop or two on a cotton swab such as a Q-Tip. These cleaners show little tendency to bleed or run if not overapplied. If the cleaned areas have not been heavily scrubbed, they can be reworked repeatedly without degrading the delicate abrasive surface of the Mylar.

Clorox and Similar Bleaches. The main use of oxygen-bleaching liquids like Clorox in the commercial printing trade is in the removal of the imaging emul-

sion from the working side of photographic film. This it does easily. However, it is also a very useful general cleaner and drawn-image remover for hand-drawn Mylar work as well, especially for some inked areas. The cleaned area should be gone over with a final clear-water wipe to prevent the chemical from effecting corrections applied later.

Household Ammonia. Household ammonia is a good general cleaner and degreaser. It is a solvent for some opaques, some inks, and some pencils.

Isopropyl Alcohol. Alcohol is a good general cleaner on Mylar. It is the sole means of removing acrylic paint and some inks. It is also a good degreaser.

Liquid Friskets

There are a number of liquid friskets on the art-materials market. Most have a latex rubber base, since they are all intended for use in masking out areas on absorbent art papers. There are also several which are intended for use on film, metal, and other nonabsorbent surfaces. These seem to have a kind of lacquer base, and are thinned not with water, but with more exotic special solvents distributed by their manufacturers.

Of the latex-based group, I have had by far the best luck with Winsor & Newton Art Masking Fluid. For me, this brand has shown the least tendency to degrade in the bottle over time, and the least tendency to come up again when the brush passes over an area already coated. It is quite thin, and should be applied to Mylar in several completely dry coats. An electric hair drier will greatly speed this process.

The most minute details can be successfully frisketed in this manner. For large areas only, it is easiest to paint in the precise outer edges of the area to be kept clear of sprayed or overpainted image, and then to cover the remaining interior area with paper or Mylar scraps, held down and sealed where they overlap the dry frisketed areas with masking or clear tape.

In a pinch, rubber cement can be used to accomplish the same results, though it will constantly show itself more willing to adhere to the brush which is trying to apply it than to the Mylar surface. With patience, however, it can be made to frisket any area.

Photo Maskoid

Photo Maskoid is a proprietary material widely used in commercial printing as a clear red liquid light-blocker on photo film, where it performs the same function as opaque. However, it can be used in Mylar-method printmaking as a frisket material by brushing it down in the areas to be kept free of image and then overpainting or spraying the image pigment. (A colorless variety of this material is also offered for use solely as a film frisket material.) When the pigment is dry, the frisket material can be lifted with Scotch or masking tape and peeled away. A reasonably mild reducer and brush cleaner for Photo Maskoid is available from the manufacturer, The Andrew Jeri Company, of Oldsmar, Florida.

Powdered Talc, Rice Starch, and Corn Starch

The extremely fine talc, rice-starch, or corn-starch powders can be used for "destickifying" tacky pigment areas on Mylar. That will prevent one sheet from transferring picks of pigment to another during image preparation or, worse yet, during plating. Rice starch also has a very important role to play during the printing stages, which will be discussed later.

Liquid Wetting Agents

Braun Non-Crawl is a proprietary liquid wetting agent carried by some art-supply stores in tiny little bottles that will last you a hundred years. It is used to overcome the surface tension, that is, the beading tendencies of some liquid pigments on the Mylar. Even a part of a drop will cause major changes in the flow characteristics of the small quantities of liquid pigments normally in use. Numerous other wetting agents besides Non-Crawl are available from chemical suppliers. Non-Crawl is formulated specifically for art uses.

Exotic Chemicals and Acids. I list these, because some or all of them are to be found in most stone

litho pressrooms today. But my list is one for saying goodbye and good riddance to all of them. The Mylar method allows the artist and printer to dispense with all these fierce acids and other nasties, all of which are extremely hazardous to health and safety.

Solvents: xylene and xylol
acetone
carbon tetrachloride and its substitutes
lacquer thinner
ether

Acids: hydrochloric
nitric
acetic
sulphuric
hydrofluoric
tannic

Erasers

Stone lithographic artists will likely envy the freedom to correct the drawn image which is so much a part of Mylar method lithography. Erasing and redrawing can be carried out on Mylar method art over and over again without any degradation of the evenness of the minute grain structure on the drawing surface, so long as the proper eraser type for the problem at hand is used correctly.

Kneaded Erasers. Kneaded erasers are soft and shapable and are the key removal and correction tool. I use them as the first step in nearly all such work, pushing straight down into the drawing and then pulling up each time a portion of the drawn pigment, constantly reshaping and turning the eraser to put down a fresh area. The eraser must be kneaded constantly, so that the graphite it lifts from the image can be folded inward and a cleaner part of its interior pulled into view and used for the next lift. When all the surface pigment which would be likely to be smudgeable has been lifted without rubbing, what remains can be *lightly* rubbed, either with the kneaded eraser, or with other types, or with liquid cleaners on a swab. It is wise to discard used kneaded erasers frequently.

White Plastic Erasers. The Mars brand of plastic eraser is common, but there are many equivalents. These are slightly more abrasive than the kneaded types. They can be used freely on Mylar, but remember that rubbing will begin to change the grain structure of the surface. Since this surface is, in effect, millions of microscopic abrasive particles embedded in the plastic coating, they can be pulled loose by the rubbing eraser, leaving little pits which not only take corrections with a different grain look but also are very difficult to clean out if further corrections are needed.

It is important to remember as well that all erasers leave an invisible gummy dust on the Mylar surface, which must be removed before corrective penciling can go down smoothly. Your finger, a cotton swab, or a small Webril pad will do this in a moment.

Electric Erasing Tools. There are several brands of small electric erasing machines on the market. They are widely used in the engineering field. Some artists use them to diffuse edges of image areas, inked areas, or to create patterns. They have the advantage of constantly abrading away their own clogged revolving tip, and the disadvantage of quickly abrading the Mylar grain surface.

Wiping and Drying Materials

The most useful wiping and drying materials are the least scratchy. Paper towels, facial tissues, printer's soft Webril-wipes and Kim-wipes are all useful in assisting to clean, wash down, and dust off. Cotton swabs do the small jobs. All are as safe to use on the printing plates as on the Mylar.

Fixatives

There are many spray-can fixatives on the market. The ones to use are matte finish, so-called workable fixes. They should be applied with the drawing surface held vertical and the spray can fifteen to eighteen inches away from the surface. Pass the can rapidly from side to side in descending bands, going out beyond the edge of the work area before reversing direction. This will avoid puddling or running. Allow time for each layer to dry before spraying again.

Only a light coating is needed to bind the drawing to the Mylar surface since, unlike paper surfaces, Mylar does not absorb any of the wet spray. It all sits up on the surface, and it will run if you overdo it.

I do not always use fixes, and many artists never do. If handled with care, Mylar graphite drawings can be constantly handled, interleaved, and plated under vacuum pull-down without any noticeable degradation taking place. The harder pencils and pigments are much less subject to smudging.

Even though many brands of spray-can fixatives are labeled "workable," meaning that you can expect to be able to correct and rework into and over the top of the sprayed-on coating, this is far from the case on Mylar. The plastic absorbs none of the wet spray, and even a light coating covers over the minute granular structure of the surface. Only the Stabilo #8008 offers much effective reworking over the fixative surface, and it will not yield the same dot-grain appearance. The answer is not to fix until you are absolutely certain you are satisfied with the work.

You may see a slight droplet pattern when the fixing is complete. This seems not to affect the plating of the image in any way. If the fixative has been properly applied, the fix layer is so thin it does not interpose a measurable thickness between the tiny dots of the actual image pigment on the surface of the Mylar and the plate emulsion to which it is tightly pressed under vacuum draw-down during the plate burn. There should be no degradation of the needle-sharp transfer of the image to the plate. Use of clear gloss plastic sprays or varnishes, however, will risk just such an effect.

Tapes

Tapes do not all do the same jobs. Clear "old-style" Scotch tape is very tough; it holds grained Mylar sheets one to the other firmly and will not permit slight shifts while you are drawing over another image, thus wrecking your color registry without your knowing it. Register pins prevent this absolutely, but sometimes they are not at hand or it is more convenient to cut a piece of another image to tape over the top of the sheet you are working on. Both the clear and Magic Transparent tapes can be used for such purposes, but an important difference is that the clear is a great deal stronger and less subject to tearing and a great deal easier to peel back up from every surface. All tapes should be used at least one inch away from any image area, so as to avoid an imperfect contact when the image is being plated.

Red Scotch transparent lithographer's tape is completely opaque to the light used for burning the image on the plate. It is very handy for spot coverage of pinholes and other masking.

Dermicel cloth surgical tape is useful for its ability to pull up and restick any number of times, but it should not be trusted to hold perfect position for color registry during drawing. I use it also for protecting the edges of the ground plate glass drawing surfaces mentioned below.

DRAWING SURFACES

Since all Mylar-method plating techniques depend on the action of light passing through the drawing surface to create the transposition of the drawn image onto a light-sensitive printing plate, all the drawing surfaces described are either translucent or transparent. Their surface texture and ability to receive and hold either solid or liquid pigments are the criteria by which they should be selected for a given piece of work.

Mylar-based Drafting Films and Similar Materials
As indicated in the note at the beginning of this book, DuPont Mylar is the registered trade name of the clear base material used in the manufacture of many brands of drafting films. It is also used as a base for many photographic film emulsions. The drafting film is utilized by engineers and designers to draw the accurate scale plans and diagrams needed for machine design and other technical illustration.

It is only a serendipitous accident that the grain structure of the working surface applied by processors of the drafting films is virtually identical to that of the finely grained lithographic stones prepared for

artists making fine-art lithographs in the old traditional manner. And it is a further serendipitous accident that positive-working, light-sensitive, factory-coated, deep-grained aluminum printing plates, the type long commonly used in Europe but, until recently, fairly exotic in the United States, have proven to be a perfect vehicle for plating an artist's fine-art image hand-drawn on Mylar. These plates, of which much will be said later, were not developed for this purpose and were quite difficult to find when I first encountered them in the early 1970s.

Since at least one of these marvelous positive plates is capable of true continuous-tone imagery and the best of the others capable of the most exquisitely delicate, clean, open printing of fine-grained drawing areas, the artist can feel free to draw anything he pleases, as finely or as boldly, as delicately or as coarsely toned as the image requires, and know that it can be plated and printed.

The standard fine-grain drafting film is produced by quite a number of submanufacturers, who add their own grain coating to the clear base film. There are also several manufacturers who can provide a number of variations on the standard surface grain pattern. At least one company produces a whole line of surface textures, some of which are impressed patterns rather than raised ones. This company is N. Teitelbaum Sons, Inc., of The Bronx, New York. Other companies that provide drafting film in several thicknesses are Keuffel and Esser, a major manufacturer to the drafting trade, the Charrette Corporation of Woburn, Massachusetts, and the Cartolith Color Corporation of Brooklyn, New York.

Generally, drafting film comes in thicknesses of .003, .004, .005, and sometimes .007 inch. I believe the .003-inch is too thin and flimsy to be used other than for small images on small sheets. When handled carelessly, the .003-inch sheet is prone to kinking in little half-moon indentations which will not completely flatten out when the Mylar art is later placed face down against the plate and pulled down under vacuum to achieve a very tight surface-to-surface contact. After seeing one of the little moons in the middle of a carefully drawn face or other important image area, the artist has no hesitation in spending

a bit more to get the more durable sheets. The .004 or .005 are excellent for any size image, but it might be a good idea to contact all these companies for samples to test. As with the making of all art, if you let the cost of your materials affect the perfection of your work, you have little complaint to make when things come out less beautifully than you had hoped.

Several manufacturers also supply these films with a matte surface on both sides. This material has some obvious interesting possibilities permitting, say, air-brush toning on one side and pencil techniques on the other, or the addition of corrections without touching the original art. However, it must be kept in mind that the doubling of the matte surface adds greatly to the diffusion and impedance of the light passing through the art image during the plating burn. An overall "plate tone" will appear on all areas of the plate as a result of short, delicate burns for delicate work. If the tone is strong enough, it will take ink during the printing. There are ways to deal with such problems, which will be discussed in later chapters. For now, it is sufficient to say that work should not be started on such material without a realization that special problems are involved in its use.

DuPont Kronar

Kronar is a proprietary trade-named material manufactured and sold by DuPont to the graphic arts trade. It is a stiff, completely clear film that acts as though it had a microthin coating of another material. It is able, to some extent, to receive waterbased sprays, air-brushing, and some pencil work executed with waxy pencils like the Stabilo #8008 and #8046, with interesting results. I have often used it for developing cloud areas composed of five or six overlapping and blending soft tones of color to give beautiful effects. I find I can go back into the sprayed work with a charcoal paper stump or a white plastic hard eraser or even my fingertip, and rub away areas and edges with very good control. If you are adventurous and experimentally minded, you will find many ways to take advantage of this material. Since

the Kronar is clear, it has less impedance to light and thus plates with a bit shorter burn time.

Stabilene Films

Stabilene is another proprietary trade-named material available to the graphic arts trade. It is a Mylar-base film which has been coated with a variety of opaque color coatings ranging from white through orange to green. These coatings are designed to be removed by the use of scrapers, scratchboard needles or liquid solvent, thereby exposing clear film areas that will burn as linear or solid image areas on the plate. Extremely delicate linear work in a scratchboard technique can be done directly with Stabilene, avoiding the film stage needed for ordinary scratchboard work, plated on negative plates.

One interesting and highly useful technique this material makes possible is to use it as both positive and negative image. The Stabilene is perfectly stable, as its name implies. If a scratchboard-needled image is burned on a negative plate, it will print the lines. If the same image is burned on a positive-working plate, all the surrounding background area will be the printing image, and the register of the two will be unbelievably sharp and kiss-fitted. Those artists who like linear work will find a whole host of adaptations for this positive/negative capacity. In fact, all Mylar-method work can be handled in this way whenever desired by the artist. Experience will bring such marvelous techniques into the artist's work more and more frequently, but with the minute, crisp needled lines of this drypoint method, the positive/negative color fitting of the precision-coated Stabilene is at its most beautiful.

There is a matching color correction fluid for each available color of the Stabilene, which is used to fill in mistakes. It can itself be then worked back into until the correction is complete.

Tracing Papers and Vellums

All reasonably transparent tracing papers and other sheet materials can be used to make Mylar-method imagery. Some will yield a very nice drawing quality to the work. The plate burn times will vary according to the relative opacity of the sheet, and must be found by experiment. A mask can be made on a separate overlay sheet, on which an opaque area just covers all details of the image drawn; if a second burn is then made on the plate with the mask accurately positioned, all plate tone from the paper sheet can be eliminated except where it is an integral part of the main image. While this may not solve all problems in the use of such materials for image-making, it can often produce useful results.

When any material is used for the imaging of a print which will be printed in more than one color, the dynamic stability of the drawing sheet must be considered; that is, the tendency of the sheet to expand and contract in width or length, or both, under the influence of any change in temperature or humidity. All Mylar materials are quite stable, as is glass, but papers, vellums, acetates, and the like are subject to much unpredictable shrinking and expansion just when you least expect it. If your work is quite loose and expressive, you may not find this of any concern at all. If your work is particularly linear, realistic, geometric, or otherwise precise in nature, use of unstable drawing sheets in multicolor images will drive you mad.

Hand-grained Plate Glass

The drawing surface of most matte Mylar films is extremely fine grained, and the depth of the microscopic peaks and valleys of the grain structure is fairly shallow. This somewhat restricts the freedom of the occasional heavy-stroking, strong-handed artist in putting down beefy, dense strokes. For such a technique, the variant surfaces available from companies like Teitelbaum and Cartolith may yield all the tooth needed. But for those artists who have a passionate love affair with the look and feel of a lithographic stone ground to a coarse, drawing-paperlike abrasive surface, there is a perfect adaptation available.

I have found that sheets of one-eighth or one-quarter of an inch clear plate glass can be ground, using exactly the same methods and exactly the same tools as those used for stone grinding, to produce a whole series of surface grain textures. They range from the coarsest, obtained by grinding

with #50 grade Carborundum grit, through the various degrees of greater fineness yielded by grades #100, #120, #150, #180, #220, #280, and #FFF (finest). The upper grades produce a matte surface as fine as standard drafting film and finer. The coarser grades yield an extremely granular surface which accepts graphite penciling with a look and feel absolutely identical to that experienced by the stone-drawing, grease-penciling printmaker of old.

Commercially available "frosted" plate glass has been surfaced by acid etch, producing pits, not grain, and is not satisfactory. Clear plate can be ordered cut to size, with the edges filed to eliminate its chipping and your cut fingers and the corners distinctly rounded.

The glass should be placed flat on a smooth, strong surface larger than the glass, to which running water can be directed even if it is from a hose in the yard. An old litho stone, a one-inch slab of particle board or plywood, or an old kitchen table are all equally fine.

On this surface, put down several layers of blotter paper, or old bath towels. Wet these down until they are soaked, and then press the glass down into them firmly. Their wet softness will protect the glass from being scratched or cracked by any dirt or carborundum grit particles which may get under the edges. The downward pressure of the atmosphere will anchor the glass firmly in place as you work.

Wet the top of the glass and sprinkle on a liberal, approximately even dusting of Carborundum grit of a grade best suited to your drawing style. The grinding is done with a small litho stone or a steel levigator of the type used for litho stone grinding. A small stone of a size somewhere between eight and fourteen inches or so is not too heavy to handle, even for slightly built artists.

Work the grinding stone, using medium pressure, in the classic stone-grinding pattern; that is, back and forth in stripes across the surface from top edge to the bottom edge, then from one side edge toward the other, then across the surface at a 45-degree angle, and then at the opposite angle. Develop a twisting, looping motion, which ensures that the surface will receive an even grinding.

Wash the slurry, formed from material abraded from the soft bottom of the grinding stone, glass particles, and used Carborundum, completely off both the glass surface and the grinding stone as soon as you feel the grit become clogged and slippery. Sprinkle on fresh grit and begin again. You will be doing this quite a few times, but the total time should be no longer than that required to resurface a stone.

You will not be able to assess the true condition of the glass surface when it is wet. When you believe you have produced a good effect, hose off the glass thoroughly, mop up as much of the water as rags or paper towels will pick up, and then fan the glass with a piece of cardboard or use an electric hair dryer. The glass will dry very quickly, and for the first time you will be able to see just how even your grinding has been. You may see clear patches here and there on the surface. These result from the slightly uneven surface of the glass. Do *not* work on those areas specially, but continue grinding the whole surface in the overall pattern. You will soon find that the patches have disappeared as the whole surface becomes ground to evenness, and the surface of the glass takes on a beautiful, pearlescent opaqueness when dried.

If this is your first experiment with glass, at this point test the grain quality of the surface by drawing a small test patch near the edge. If the results are more or less grainy than you expected, you can alter the surface by continuing the grinding with a different grade of Carborundum until you are satisfied.

When the surface appears perfect, rewet it and scrub it down gently but very thoroughly with a household scrub brush and water to eliminate any possible remaining grit particles from the surface, edges, and underside. Then blow dry.

The glass is now ready for use, but you would be most wise to protect the edges from chipping or cracking by applying Dermicel tape all around. You should also protect the grained drawing surface with a cover sheet. I use Mylar. It is work to grain the glass, and a single careless scratch means re-graining. However, a well-cared-for glass can be cleaned off by thorough scrubbing with the cleaners,

solvents, soap and water, and a scrub brush, and re-used many times. Try *that* with a stone.

If your glass appears evenly grained but the level still slightly uneven in spots, don't worry. The metal plates will conform to its surface under the great pressures of the vacuum used to contact them during the platemaking. You can use the old stone printer's test of standing a metal straightedge on edge on various parts of the surface and sliding little slips of thin paper beneath it. If the paper is gripped in one place and is completely free in another, it would mean trouble on a stone but probably not on the glass, considering the relatively flexible aluminum printing plate's ability to bend itself to conform to the glass's topography. Certainly, there is a point where the unevenness would require regraining, but in fourteen pieces of ordinary commercial plate I have grained I have not found one that was not perfectly usable.

This grained-glass surface is marvelously abrasive to all drawing pigments used on it, yielding beautifully toned drawings of great sensitivity. Additionally, it has the same satisfying feel known to stone lithographers, which is really a tactual sensing of the pressures being applied in every tiniest movement of your point. If you have grained your glass properly, nobody in this world will be able to distinguish any difference in appearance or tone quality from work pulled from a similarly grained stone.

Corrections are made on the glass during the work in the same manner as on Mylar, and all the same family of materials and supplies can be used.

Rubylith and Similar Mylar-base Materials

Rubylith is a proprietary trade-named sheet film used by commercial photolithography strippers to make overlay masks. It is a Mylar-base sheet of the same range of thicknesses as drafting film. The earlier comments about the utility of thicknesses apply, with the .004-inch being the best safe standard. The red coating on one side is designed to be easy to see through on a light table but opaque to the plate-burning light. The coating can be lightly cut with a blade, and sections as tiny as a penline or as large as the whole sheet can easily be peeled up. Quite intricate masks can be cut in this way. I have often made the art for various flat-color areas from Rubylith rather than by brushing opaque on Mylar.

There are many brands and special varieties of these transparent red-peel-coating Mylar-based masking materials on the market. Some are cheaply made, and the edges of the red areas tend to shrink back very slightly from your original cut. The cheapest will insidiously destroy tight color registration. The good types cost more, and are thicker. Some suppliers carry .007-inch material, which is superb.

I can personally vouch for this list of the most useful tools and materials for Mylar-method image-making after ten years of concentrated work and well over one hundred editions of all kinds, most in many colors. Other artists have used other materials, such as certain colored pencils for drawing, various markers, and so on. I hope you experiment to find other ways to make beautiful, reliable images. In the meantime, however, nothing in this list will waste your time, or prove less than effective, if you think carefully about the suggestions for their use that I have included.

You could easily do a lifetime of fabulous printmaking and never need half of what I have included here.

Figure 1. The Mountain Men, *by Paul Callé. © Paul Callé, 1981.*

Paul Callé is the foremost practitioner of pencil drawing of our time. All the fluency of technique outlined in his book, The Pencil, *finds perfect replication in this big, bold, perfectly captured double portrait. And this is just in one color.*

Figure 2. Man Without Fear, *by Merv Corning. © Circle Fine Art, 1979.*

This magnificently conceived and executed print was built in fifteen passes through the press. The artist relies on extensive modifications to the plate on the press to use the same mounted plate to overprint decreasing parts of its image in follow-on colors. This yields superbly toned soft gradations of colors uniquely his in style. This is color printmaking in the hands of a confident master of the medium.

Figure 3. Placid Way, *by Michael Knigin. © Michael Knigin, 1981.*

Michael Knigin has been working with Mylar since its very early days, and teaches the technique at Pratt Institute in New York. He has made scores of prints using every variety of artist's technique. Placid Way *is in fourteen colors, and was printed on the big Marinoni flatbed direct press at the American Atelier, in New York. Michael is coauthor, with Murray Zimiles, of a very useful, straightforward textbook on stone lithography,* The Technique of Fine Art Lithography. *With this background, he is in a unique position to see and adapt the best of the traditional methods to this new family of lithographic materials.*

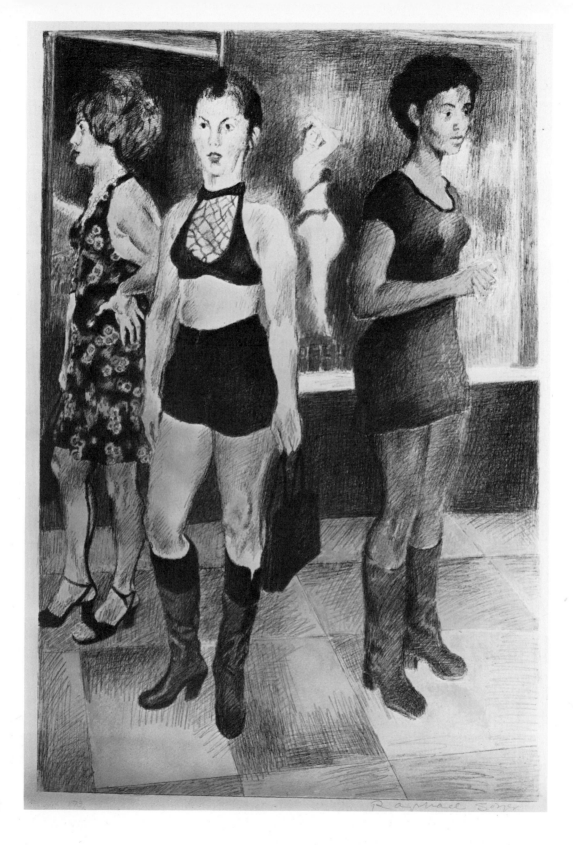

Figure 4. Eighth Avenue *by Raphael Soyer © Raphael Soyer.*

Raphael Soyer is a most venerable institution of American painting and printmaking. He made his first lithograph—a self-portrait—on a press in his own studio in 1917. He continues a steady flow of lithographic prints, interspersed with his paintings, even today, sixty-six years later.

Eighth Avenue, *though quite typical in subject matter of hundreds of Soyer print studies of New York life, stands nevertheless as a milestone in his work. In it he took advantage of the Mylar method's inherent ease of conception and preparation of added colors. He did his overlay tusched washes for the additional colors on a table next to the press at the American Atelier (see Figure 5).*

Figure 5. *Raphael Soyer at work. Photo courtesy of Lee Rexrode.*

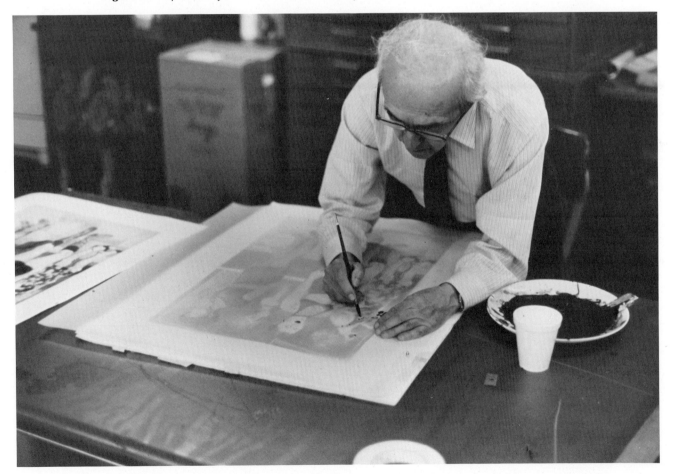

Figure 6. Nureyev, *by Jamie Wyeth.* © *Circle Fine Art Corp., 1978.*

This large (twenty-four-by-thirty-four-inch bleed) eight-color image is a lovely example of the free, easy drawing style of this artist. This is what Jamie has said of the Mylar method:

"I don't like the mechanical complications of drawing on stones and plates, but I find drawing on the Mylars a free, expressive, creative experience. Working on one drawing over the other brings the color realtionships readily into view, as the print develops, something which I find must be much more clumsily approximated when the artist must draw on opaque heavy stones and zinc plates.

"In the Nureyev print, I was not satisfied with the arm, and especially that expressive, suggestive line which leads away to the right of the figure. On Mylar, I was able to redraw that line over and over until I really got it to work the way I had visualized it. The freedom to keep improving the drawing would be impractical on stone, and I probably would not have undertaken my recent series of lithographs at all, had not this Mylar method proved so adaptable to my own painting and drawing style."

Figure 7. *The artist's edition #74,* The Doll House. © *Mel Hunter, 1978.*

Printed in twenty-four colors on the large Marinoni flatbed direct press at the American Atelier, in New York. This image piled up dense transparent colors one over the other to produce a rich, vibrant image redolent of the lush, old-fashioned garden of this jewel of a Vermont house. There are seven different green inks overrunning and blending in various areas of this print, yet ink refusal or plate misbehavior when printing into tacky inks was never a problem with the Howson plates used for its creation.

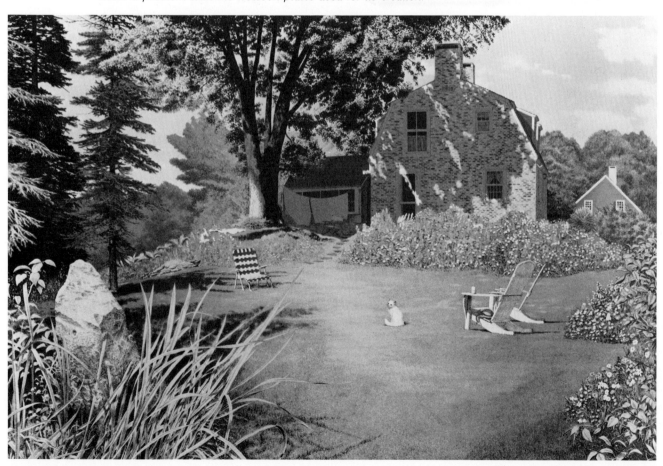

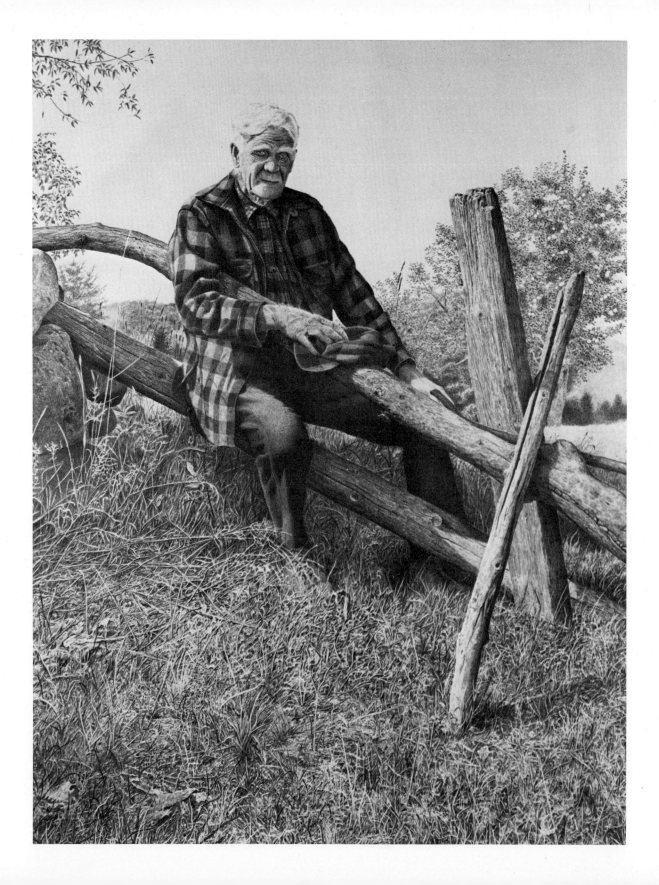

Opposite:
Figure 8. *The artist's edition #103,* The Woodsman. © *Mel Hunter, 1981.*

This image is a portrait of a respected friend of the artist in Vermont, with a face, body and manner honed over eighty years of rigorous outdoor life. The key drawing carries the delineation of textures about as far as it can be taken with pencil toning. It stands as an example that the artist can devote a great deal of work to a piece with no slightest fear that the press will not convey what he has created. The key was printed twice, building the deeper tones without any trace of filling in.

Below:
Figure 9. *Enlarged detail of* The Woodsman. *The circle represents a dime in scale.*

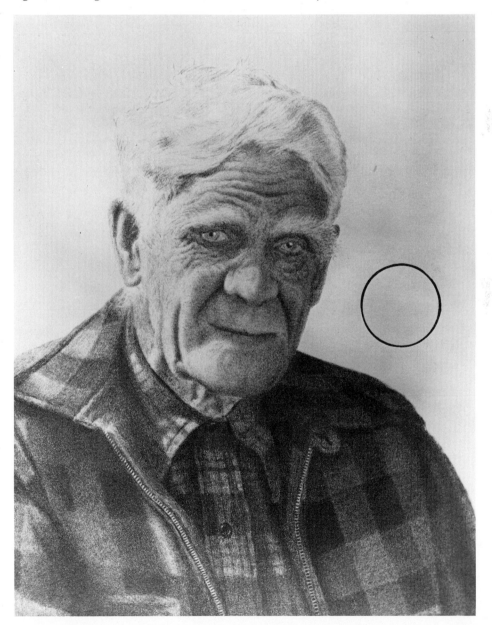

Figure 10. *The artist's edition #75, The Patriarch. © Mel Hunter, 1978.*

This was a very large image, measuring twenty-two and one-half by thirty inches bleed all sides, including the lower deckle edge. In thirteen colors, the print had three key drawings, printed separately in progessively lighter tones of gray for three zones of foreground, middle, and far distance. The foreground key was drawn with crowquill pen and Pelikan tusche on Mylar, and shows the easy pen technique possible on these surfaces.

Figure 11. *Foreground key to* The Patriarch.

Figure 12. *The artist's edition #104, Gloria Reading.*

This edition was developed and proofed on the Brand hand press by the artist. As shown here, Gloria was printed in nine colors, with the key being printed twice.

Figure 13. *Here is the same image, as later somewhat refined and printed in fifteen colors on a Heidelberg offset press at the Polaris Workshop. The register of colors is perfect in both cases. The density of the hand-printed image was by choice, and was due to greatly more absorbent paper chosen.*

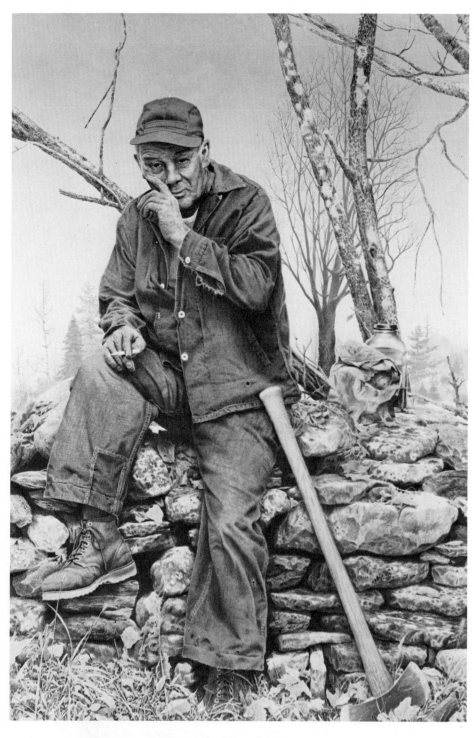

Figure 14. William Bliss, Vermonter.
©
Mel Hunter, 1981.

This large, ten-color portrait of a marvelous old country gentleman in the rough stands as a virtual checklist of special techniques brought into the printmaking artist's reach with the advent and maturity of the Mylar method. These include perfect register overall, perfectly matched soft edging of all colors at the perimeters, double hitting of the major colors, softening of all flat color areas by double burning their plates with random spray masks, use of graphite rubbing for delicate veils of rosy flesh tones, large and evenly graded sprays perfectly masked to fit around foreground objects, rainbow rolling and, especially, beautifully graduated deep pencil toning on the key which plated and printed with exact fidelity to the drawing.

The artist believes this image to be his finest.

Figure 15. Here the artist holds by two fingers the total weight of a large key drawing on two ounces of Mylar and an excellent portable drawing board for use with it, made from six ounces of white framer's Fome-Cor with two layers of Mylar taped to it all around the edges. This system replaces the four-hundred-pound stone resting on the hydraulic lift necessary to move it about. On a large ten-color print, the handling difference is about thirty-nine hundred ninety-five pounds. Since the Mylars are also extremely durable, it is not unusual to see an artist come into the shop with one or two complete color editions in a rubber-banded roll under one arm.

Figure 16. The artist often makes some or all of his printing plates in his own platemaking room at Atelier North Star, taking them ready for the press to the print facility where the edition is to be run. Shown here is such a plate which has been punched on his homebuilt punch machine. This plate was later used to lay down a spray image of gray clouds and fog in the sky, and a gray undercolor in the trees of his edition #101, Lucky Lady. The punch machine is built by insetting three standard Wilson-Jones "Marvel" office punches in a two-inch-thick plywood platform, and linking their handles with a wood bar.

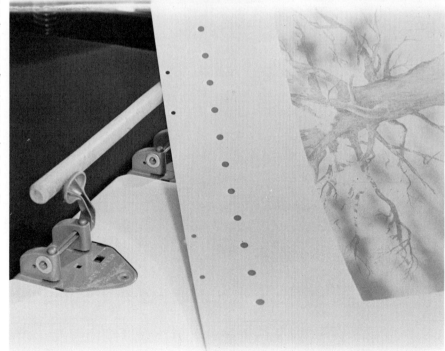

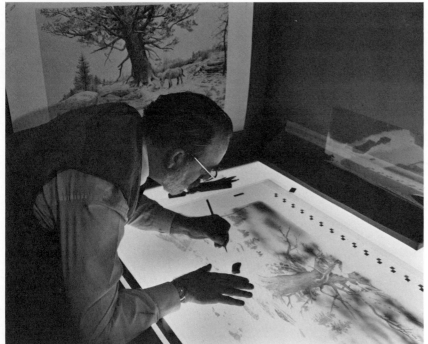

Figure 17. *Here the artist works on two Mylar drawings for various colors to be added to the partially printed edition of his print* Lucky Lady. *A progress copy is pinned to the wall for reference. The clouds and distant trees are being fitted around the image of the key drawing. All three Mylars are placed on the register pins. The little color squares are useful for checking evenness of ink densities during the press run, and will be trimmed off the edition sheets later. Hands touch only where no drawing will be needed.*

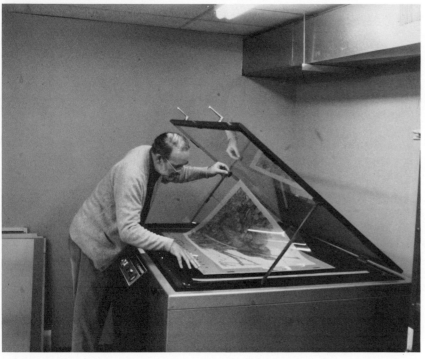

Figure 18. *The artist prepares to burn the key plate from the Mylar drawing for his edition #100,* Willis Bliss, Vermonter. *Platemaking machine is a standard flip-top type used by most commercial offset print shops all over the country. Though less flexible for close exposure control than the homemade platemaking rig diagrammed on page 43, these machines can make beautiful Mylar-image positive plates of great fidelity to your art if you do not draw too lightly and if careful burn estimation tests are made not from printers' test strips, but directly from your own art in the machine.*

CHAPTER TWO

DRAWING

PLANNING AND PREPARATION OF ART

I think most artists who complete their first lithograph are suddenly gripped by the sense of finality of the printed image on the paper. No more refinement or correction can be given to their brainchild. It follows then that every flaw or impediment to perfect, easy imagemaking is best anticipated and prevented at the outset.

The very best, least-flawed drawings on Mylar will be done over smooth, slightly cushiony undersurfaces specially prepared for Mylar work. The Mylar sheet is stiff, with very great resistance to stretch or tear. If a grain of grit gets beneath it, your pencil point will feel a considerable bump going over it. If you pass your finger over the area, it will feel like a large pimple under the surface. Dirt grains seem to come from miles around just to get under your drawing. If you work on your Mylar over an unyielding drawing board or glass surface, this can create a real problem.

Years ago, having fought this long enough, I devised two custom drawing undersurfaces that give both a slight springy feel to the drawing-pencil stroke, as when drawing on a paper pad, and generally seem to avoid the grit magnification problem.

The first of these surfaces is opaque. Some artists feel best when drawing on an opaque white surface, so for them this should be a fine solution. The surface is composed of a sheet of white Fome-Cor, (a three-sixteenths-inch ultralight backing-board material made by Monsanto for use in picture-framing and the graphic arts), on which three sheets of matte Mylar have been taped all around the edges. Using only one sheet of Mylar will allow the intense pressures of the pencil point to rapidly dent and deform the Fome-Cor beneath. For me, three sheets proved the most durable.

Take time to be absolutely sure that no dust particles are trapped between the layers. Once the top Mylar is taped down all around, no grit can get in.

This surface is resilient but extremely durable, cleanable between projects with a liquid cleaner like Fantastic or light soap and water, and gives a very satisfactory precise feel to the work. A big sheet weighs only a few ounces and can easily be transported in one hand even with a dozen Mylar drawings taped to it when it's time to go on location to sketch or draw, or to take everything to the printer to begin platemaking, where it serves as a perfect portable drawing board for corrections.

The amazingly light weight of this whole edition-making kit is worthy of note. In the days when I was making major edition stone lithographs, I was forced to hire two strong men to move the 300- to 400-pound stones in their specially built wooden crates from my studio down a winding staircase to my car, which could only carry the weight of two at one time.

After converting permanently to Mylar work in 1975, I was content for a number of years to work on this Fome-Cor opaque surface. I loved its easy portability, and I made many fine editions on its surface, occasionally taping up a new one when

age and use gradually made the surface bumpy and dim. But eventually I came to realize that my style of realism, dependent as it is on carefully controlled relative tonal values, needed an extremely precise match between the value of a gray tone I saw when drawing it and the value of that same gray area seen by the "eyes" of the printing plate that later received the image during the plate burn. These plates are not human artists; their "perceptions" of drawn images, though reasonably close to human standards, need to be allowed-for while the drawing is being made.

When working by daylight, reflected from this "frosted" material lying against the white opaque background board, I tended to overdraw a bit, making areas darker and more filled-in than I intended them to appear when printed. The combination of the reflectivity of the Mylar and the shiny way graphite reflects when drawn on its surface caused this. However, ordinary commercial printers' light tables, too bright to do prolonged work upon, seemed to make the same gray tone area appear *lighter* and more open than I intended it to print. A dot of pencil tone that appears black in reflected daylight appears semitransparent gray when backlighted on such a standard bright light table. The plates seem to "see" the dot somewhere in between.

I began experimenting to find a way to combine the best features of both. As a result, I now use exclusively my second suggested working surface, a kind of subdued light box.

If your image-making style is not dependent on very accurate tonal judgments, you may find the Fome-Cor surface a perfect drawing base for Mylar or any other kind of studio work. But if you need close, accurate tonal control, I suggest you experiment with the quick temporary rig I describe below. If its appearance and feel work for you, then you may want to spend the moderate time and money needed to build, or have built, some version of the portable light box shown in figure 23 on page 57.

Most commercially made light boxes or tables cost many times what it takes to make this box. All are extremely heavy and have neither the right light nor surface for this work.

The quick test rig has both. Essentially it is a large sheet of quarter-inch plate glass with three sheets of matte Mylar taped all around to its top side, and three additional sheets taped all around to its bottom. This is placed on a bridge of two two-by-fours for strength. These in turn are laid across the gap between two level table tops or tabourettes, or even two folding card tables. Beneath this gap, any fluorescent fixture of medium length—twenty-four to forty-eight inches—can be used, bulbs turned up. A number of incandescent bulbs can be rigged to do the same job, but their light will not be quite so well diffused. The six sheets of matte Mylar greatly reduce and even out the light and pleasantly warm its color.

This whole assembly can be set up, and taken down if your studio is crowded, in two minutes. Mine has remained set up in my studio for two years and I have worked on it for many hundreds of hours, producing large, perfectly toned Mylar drawings of every type. Between editions, I use it as a business desk. I recently flipped the glass over, and I can use the underside for another year or two before recovering.

The portable light box in figure 23 on page 57 never fails to bring queries about where it can be bought whenever I take it anywhere. There are many more photographers and graphic arts workers than printmakers in this world, and they all seem to need some version of this box.

The portable light box is built from 1″ × 6″ pine, half inch plywood, and two sheets of one-eighth inch plate glass. The glass sheets are separated and sheets of matte Mylar are taped on each plate to gain further diffusion and even out the light from the very close positioning of the bulbs. I use G.E. Brightstiks, special bulbs with no heavy ballast transformer and extremely light in weight. However, they are subject to failure from high temperatures and consequently, as shown in the diagram, the box must have extensive ventilation. If you fudge on this, you can expect rapid replacement of expensive bulbs. The six Brightstik bulbs shown are the maximum number that can be wired in parallel on one circuit and plug. Though the six use very

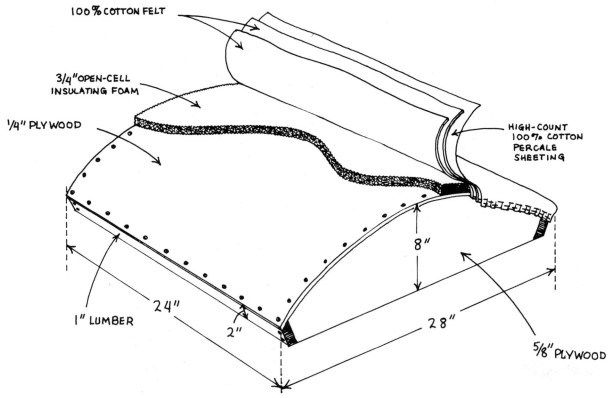

100% COTTON FELT

3/4" OPEN-CELL INSULATING FOAM

1/4" PLYWOOD

HIGH-COUNT 100% COTTON PERCALE SHEETING

8"

24"

1" LUMBER

2"

28"

5/8" PLYWOOD

M.H.

THE DAMPENING ROCKER

Shown is the diagram of a medium-sized dampening rocker used on medium-sized plates on the hand press. The area of plate surface this size rocker can efficiently cover is about twenty-two inches in width and twenty-four inches along its curved length. A well-equipped shop could use a larger size, such as that shown in Figure 44. This version measures twenty-six inches across and thirty-six inches along the flat edge of its curved side. Lightweight construction, as is visible in that photo, keeps this large tool light enough for one man to manipulate, but rapid edition printing would be speeded with the assistance of a helper.

The purpose of the soft foam underlayer (the original purpose of which is as insultion in air conditioners) is to cushion the surface to allow variations in downward pressure to pick up excess water on the plate surface, or to force additional moisture evenly out of a large area of the absorbent cotton felt pads beneath the sheeting. Drowning the rocker with too much absorbed water defeats the first purpose, leaving the plate consistently too wet; and spotty or inadequate moistening of its absorbent cotton defeats the second, leaving the plate consistently or irregularly too dry, leading to immediate scumming.

Caution The use of felt pads or sheeting which are not 100% cotton greatly reduces the efficiency. Cotton can take up and hold large amounts of water, and release it, either to evaporation in a slow and predictable manner, or evenly under pressure. Synthetics and wools do neither.

Check the plywood curved surface for inward dishing. Brace from inside if needed. Epoxy enamel three coats. Glue the foam to curved ply with spray adhesive and trim off excess. Stretch the first layer of cotton felt down over the edges and staple with a carpenter's staple gun. Trim off excess. Stretch second layer of felt, pulling and smoothing with your hand to overcome the considerable friction so that the second layer is very tight and without wrinkles. Staple just below the first staples and trim off excess. Stretch smooth cotton sheeting in the same manner and staple further down. Trim.

If rocker is always sprayed to dampen well before printing begins so it is evenly dampened, it will not pick up ink and should not need replacement in many thousands of impressions. Replacement takes less than thirty minutes. The rocker itself should last many years.

little current, this limitation has to do with the precise inflow of current needed to start them, which can be divided by no more than six.

I can carry this box up and down stairs with little problem. I often take it to the printer while editioning, or carry it back and forth from the pressroom to my hotel room when I am away from home at a distant printer, and overnight corrections to the Mylars are necessary.

Since settling on the use of this type of subdued-light working surface, I have had a perfect marriage between my judgment while drawing and the tonal sensitivities of the various top-of-the-line positive-working plates that I use to plate and print my images.

One further point needs to be made about drawing on opaque surfaces. Working under artificial light, which many artists do, makes tonal judgment even more difficult than in daylight, again because of the tendency of the diffusive, reflective Mylar surface, and the graphite pigment drawn on it, to reflect such light in odd ways. Use of the soft, underlighted surfaces solves this problem instantly, day or night.

SETTING UP

Most artists in any medium have their own personal way of sketching out, roughing in, underpainting, or otherwise setting up some preliminary guide to beginning the main work. Some artists dive right in with no such visible preparation. Not all of us are such virtuosos, so we depend on visual preparations to help avoid the complications of corrections and changes later.

As an artist of many years' professional experience coming to my first lithographic stone, more than a decade before this book, I found the need to transfer preparatory drawings manually to each separate stone or plate to be a real pain. Particularly since later they would often turn out to have been less than perfectly placed for good color registration. I made more than fifty editions on grease-drawn stones and metal plates, most in many colors, in addition to many test projects, so I had plenty of experience with the whimsical, tyrannical flicks of the barbed tail of The Great God Lithograph.

But since that time, the magnificent ease and freedom of slipping a tracing-paper rough sketch under a translucent sheet of Mylar and drawing a finished version immediately have been wonderful. And then, to be able to lay another fresh sheet over the top of that drawing and precisely fit every part of another color to it with whatever degree of minute control and color registry I wanted—that has been *liberation*!

Stone lithography is made only on direct-printing presses, whether powered by hand or by machine. The artist must always draw the image backward— that is, reversed from side to side. A mirror to constantly check the image is often a necessity, especially if the art contains numbers, type, or other nonreversible details. Mylar work, on the other hand, is burned onto printing plates which can be printed on either any direct-printing or offsetting litho press, whether it be flatbed or rotary.

Many lithographic artists believe that offset printing cannot achieve the color richness of grease-drawn direct printing, but many, many gorgeously rich-toned, strikingly printed editions have been produced by offset methods. The point is that the artist now has free choice of which press and which method to work for. A preliminary drawing can be perfectly read on the light box, whether in its face-up or face-down position. Mylars can be flopped in an instant and details read either way. The artist does have to decide at the outset which way the image will be faced because all plating must be with the Mylars face down against the plate surface, but visibility, registry, and perfect understanding of the image as it progresses is routine.

CONTROLLING COLOR REGISTRY

Commercial printers all use a standard type of register pin, a little flat metal plate on which is mounted a

round metal cylinder a quarter-inch in diameter. They are of several different heights. Those pins about a quarter-inch tall are best for drawing, when you may want to pop on and off as many as three or four punched Mylar sheets, one over another, to consider your work in progress. Those pins about three thirty-seconds of an inch in height are used under the glass of the vacuum frame when the Mylar is registered to the plate, which itself may be pre-punched and set up for exact registry on the press so that everything matches with ease at every step.

In preparation for drawing, I cut as many clean sheets of Mylar as I think I may need for the edition. I take care to keep my greasy fingers (so are yours) off the matte working surface, handling the sheets only by the edges. The first sheet I prepare as an overall ruled-out guide sheet for the whole edition. Using a big triangle and a thirty-six-inch metal straightedge, I lay out the intended image area of my print, the intended margins of my chosen paper, the gripper edge, if the paper is going to be printed in a press with a gripper mechanism, and several inches of unused space all around the edges.

At the top edge, I take a standard hand-grip office-type quarter-inch punch and make three holes about a half-inch in to hole-center from the top edge of this Mylar, one in the ruled center of the sheet and the others about two-thirds of the way out toward either side. These three punched holes will provide the key to perfect register of everything that follows.

Next, I cut out one-inch squares from the top edge of all the other Mylar sheets for the edition in the position of the punched holes on the ruled-out guide sheet. From a scrap of Mylar I cut a series of 1.5-inch squares and punch a centered hole in each a half-inch in from one edge. I then flop the guide sheet face down, insert three register pins in its holes, place three of the little punched squares (also flopped) on the pins, and then place down a flopped sheet of Mylar positioned so that the cut-out notches are overlapped by the squares. Using *clear* cellophane tape, I securely tape the center square to the notched sheet. Working flopped, the tape is first applied to the smooth surfaces and gets the best grip. Then I carefully smooth the sheet

outward toward the outer pins to remove any buckling, and tape each square.

The sheet is then flipped back, working-face up, and taped on that side. It is now very securely pin-registered to my guide sheet and safe to handle on and off the pins. It would seem easier to use the guide sheet's punched holes to locate and punch holes in all the other Mylars. But doing that risks deforming the guide sheet's holes, the precise tight fit of which is vital to the whole job, and also risks punching the edition sheets with slight shifts and slack between holes. Either of these tiny missteps can wreck the sure color register of the whole edition. The long way is safe and reliable. With the money and time involved in color lithography, the sure way is the only way.

Commercial printers purchase big precision three-hole punch machines, which can cost over a thousand dollars. Your work, registered by the above method, will stand beside theirs for easy control. If you like, you can build yourself a very efficient three-hole punch by countersinking three standard office desktop punches into a thick plywood base and linking their handles together, as shown in the photograph of my rig on page 29.

Register pins are by far the most accurate, fail-safe means of insuring accurate placement of the work at all stages. If, however, you do not choose to use them, you can easily set up register marks. On the guide sheet, well outside the margins of the image area, rule in at least three small crosses, one each on three sides of the work. Use a fine pen or very sharp pencil point. If the edges of the edition paper are to be trimmed when printing is complete, try to fit the crosses in those trim areas so they can be used during the printing of each color to insure perfect printing placement.

As each Mylar sheet is set up for drawing, it should first be positioned and taped down over the guide sheet and the punched holes conformed as described above, the register crosses should be drawn in with great care to exactly overlay those on the guide sheet, or both. Also, the outer edges of the image area should be very lightly ruled in so that as the work progresses on every color you will always

know how far out your image can go or needs to go if it is to reach the image perimeter. You will not need to stop any color precisely at that edge; you should actually extend the work out beyond that ruled line a bit, as will be explained later.

DRAWING THE IMAGE

At this point, you are ready to begin your edition. If you have made a sketch or layout of your intended image on tracing paper, bond, or Mylar, you will have had plenty of opportunity to change, refine, reposition, and clarify details of your intended image. You can continue that process of refinement, because Mylar work is correctable to any extent necessary. To begin with everything in best workable position within the boundaries you have laid out, first position the guide sheet, working-face up on the taped-down pins. Then, you might want to tape down your rough sketch or layout in best position. When you then put down your first Mylar sheet, you will get a diffuse but clear view of the sketch beneath it. If you intend to work in very fine light pencil and you find the strength of your sketch lines obtrusive, run another piece of Mylar up beneath your drawing sheet. Your sketch will recede in contrast but will remain quite visible. I often like to make mine just barely visible to give me a suggested guide that still leaves me quite free to vary my finished work considerably.

If you choose to rough in your subject right on the finish Mylar and correct and erase the light sketching as you go along, the above arrangement works perfectly. I am trying to indicate to you that you can work as tentatively or as boldly as you wish, as methodically or as intuitively. The medium is tremendously flexible. But if you are hasty or careless with the registration of extra colors, you will probably regret it at the end.

More often than not, I make a main "key" drawing designed to print in black or shades of darkish gray or brownish-black, so that all the salient details of the image will be clearly defined. All additional colors are then fitted to the key drawing. But this is just my own style of work. Many other artists use completely different methods of image composition. Some work in a close simulacrum of watercolor technique, using color areas entirely without linear definition. Doing this works just as beautifully for them. I often combine elements of both approaches. I complete my key drawing and use it as an underlaying guide as I make all the many colors for a complex edition. Then I print all the colors one by one, building up a full-color image, and print the key last, often with many areas deleted or greatly subdued. Used this way, the key is more to tie the colors together than meant to stand out as a sharp linear dominant drawing. Obviously all colors in this method must register exactly. The results can be lovely.

Whatever your own approach evolves to be, developing an effective color lithographic style will depend on the extent that you learn to visualize the various values of the color you intend your drawing to produce as you are making it in black pigment on the Mylar. This is the indispensable mental adjustment all color printmaking requires of the artist. Much of the creation must take place in your mind before you ever see it. Once one of your color drawings has been plated and proofed in the yellow or peach or blue ink you intended it to be, you will make a quantum leap in judgment and experience for the next. Nothing can shortcut this for you, but if you are a printmaking artist you will easily learn to anticipate the results.

If your style of making art is that of "action painting" or wet washes in various other mediums which depend on happy accident, you can certainly produce such work in Mylar-method lithography. If you feel the need to see the effect you are working for in a tangible form first, the procedure used by the chromist (copyist) (whereby a full color sketch or painting is first made of the subject and then carefully analyzed and broken down into its constituent color parts) is very effective. If you approach your own prints this way at least the first few times you assay a color lithograph, you will learn a great deal about how the printmaking process at its best can work.

But whatever way you work, if you begin with projects that are not too elaborate you stand a better chance of learning as you go without the discouragement of getting in over your head too soon.

When I first began making color lithographs, I made a very complete watercolor painting first, and then I set out to recreate it as accurately as I could in printmaking terms. In Europe, work of this sort is often carried out by a very special, highly skilled craftsman called a *chromiste* (in the United States, it's "chromist"). In fact, a large majority of the master prints bearing the signatures of most of the world-famous European art superstars of the last century have been made by chromists working anonymously to recreate the famous artist's painting as an "original" print. They are very good at it; it is they, and not the artist, who have taken the time to learn how to create color in printmaking. In actual fact, it is *their* "original" print, not the artist's, but nobody wants to talk much about that.

Perhaps you are or will become confident enough to go directly to the printmaking process without trying to duplicate an existing piece of your own work. That is true printmaking. In that case, color for color, problem for problem, working on these correctable, visually checkable, overlaying surfaces can raise your sights from initial black-and-white imagery to full-color printmaking. That is a real thrill and an advanced skill.

MAKING A BURNOUT MASK

If your first project is designed to be a black-and-white image and you have completed the actual drawing, you are ready to make the plate—except for the possible problem of the edge of your image area. Here is where using the technique of the burnout mask may be a real asset in your planning, whether your print is of one or twenty colors. The same burnout mask would be used on each color, as its plate is made.

This double-burn masking technique consists of making a separate Mylar, Kronar, or red Rubylith overlay sheet pin-registered to the ruled guide sheet or with accurately overdrawn register crosses, or both. If your image perimeter is to have a sharp, clean edge, you create it on this sheet by filling in the whole image area with opaque on Mylar or, if you are making the mask from a Rubylith overlay film, by cutting and peeling away all the margins to leave a sharp-edged red film solid area.

If your image vignettes softly against a clean paper background, you can draw in a soft-edged overlay mask with tonally penciled or sprayed vignetting edges that protect all your art area but leave all nonprinting areas completely clear.

I make most of my prints with the complete image area on the paper covered with image in one or more colors—without what is called "interior vignetting. However, I like to soft-edge the complete image all around its perimeter, even if many colors must be made to fade away with perfect precision one over the other. Figure 26B on page 59 shows such a soft-edge burnout mask and how it is used to accomplish this. Each color drawing is first burned on its plate, and then the glass cover of the vacuum frame is lifted, the drawing removed, and the burnout mask registered in place on the pins protruding through the punched plate. The vacuum contact is renewed, and an additional burn is made which doubly cleans out all the nonimage area, guaranteeing completely clean paper margins and also creating a diffuse, soft edge all around the art. If the mask burn is for the same duration for each color, the soft edge will be beautifully uniform. The same technique produces perfect interior vignetting.

That explains why I suggested earlier that you extend your image drawings a bit beyond the intended edges—so that the burnout mask can match the edges of all the colors evenly.

If you are using register crosses in areas that will trim off later, then you want the marks to be protected from exposure to the plate-burning light during the mask burn. You will need these crosses for checking registry on the press, even if they must be positioned in the print margin until you are proofed and ready for the edition run. Cover the crosses with red tape on the burnout mask. You can remove the marks

from the plate at any time with a chemical image remover.

CREATING EXTRA COLORS

If you plan an image to be in more than one color, all the techniques I have described apply to the preparations. With those registration systems you will have no difficulty getting your color areas to print exactly where you intend them.

Bear in mind that tonal areas meant to print in medium- to light-colored inks—say, 50 percent gray tone—will appear pretty strong on the usual white or pale edition paper if printed in undiluted black ink. But if the same plate is inked up with a pastel tint of blue or pink or any light value of any color, that 50 percent tone area will yield a printed image that appears extremely weak and washed-out. Each tiny dot of ink is printing with its same quantity of ink, but the value contrast between it and all the surrounding pale paper is much less, and visually it is overwhelmed.

If you bear this idea of relative contrast in mind as you create toned areas for your colors, it will greatly help you adjust the tone values you need to make your image come alive as you want it.

Obviously, an additional color can be created by drawing it from scratch. But sometimes you can use an already created color drawing to make an additional color area if you alter the drawing in some way. When the original color has been completely printed on the edition, often you can achieve a useful color addition by adding to the drawing on the Mylar, by erasing parts, or by cutting parts out.

Having said this, I want to suggest an additional use for burnout masks which makes maximum use of all the color drawings. A custom burnout overlay mask can be created which will hold a part of a just-plated image and permit the plate-burning light to pass through it to burn an exposed area out totally. If for the second burn the mask is placed instead over the top of the original Mylar still in place on the pins, it will simply allow for the greatly increased exposure of the unmasked area. The plate-burning light, in this case, progressively eats away through, around and under the edges of unmasked image dots, thus weakening that image area so that it will print lighter and less well defined.

There is a second and most elegant way to mask for second burns on a plate, one that I love to use. Any drawing image, even a key, can be softened and caused to print less crisply by making a second burn in any area of the plate with the original Mylar removed but with the mask contacted face down to the plate. The mask in this case would be a Mylar sheet with a large, evenly toned sprayed or airbrushed area of about 50 percent coverage. I make such sheets by setting my large airbrush on a somewhat coarse setting and making large, distant sweeps until the random dot tone gradually builds up. Once made, such a sheet can be used many times, but be *very* sure your Mylar sheet has never been touched by greasy little fingers in the area to be sprayed. All such invisible touches seem to reject the spray. Start again. Good spray mask can be made on either matte drafting film or clear Kronar.

Such a spray overlay mask used during a second burn causes all image beneath it to become softly broken up by the light passing through the tiny interstices between the black dots on the mask. This will convert a solid area into a soft half-toned area or will convert a crisp pencil or pen line drawing into a misty, less contrasty version of itself.

One beautiful adaptation of this interesting technique is to burn the main drawing to print a very crisp and sharp, perhaps slightly overburned image on the paper. Make a second plate from the same art, with the drawing burned somewhat *under* the usual value so that it would be deeper toned and perhaps a bit filled in in the darker areas. Make the second burn with the spray Mylar or Kronar mask on the second plate. When this now modified plate is developed, it will appear much less sharp but with much more area coverage.

The two plates are printed, their images falling one over the other on the sheet. If the main needle-sharp key image is printed in a black or very dark, rich color, and the second version, plated as a "fatter,"

softer image and very carefully registered dot-for-dot with the first on the sheet, is printed in a lighter color—perhaps a sepia or a medium blue—then a marvelous duotone image emerges. This is a type of elegant image making never seen in hand-drawn fine-art prints before Mylar techniques made such microscopic register possible.

There are other ways to use this double-burn and spray-mask technique which will undoubtedly occur to you as you experiment. Think about positive/negative combinations! I'll leave you the fun of discovery.

Any questions about plate-burning, exposure times, and so on, the understanding of which is integral to the above descriptions, will be answered in the next chapter. It deals with the conversion of your art images into positive- and occasionally negative-imaged metal printing plates capable of printing your work superbly. You are going to understand it all.

CHAPTER THREE

PLATEMAKING

In an earlier chapter I used the splendid word "serendipitous" to describe the unforeseen value of Mylar-base drafting films in ways that are a great improvement over methods used for traditional stone lithographic imagery, especially with full-blown multiple colors. Most of the manufacturers of this engineering drafting material greeted word of the obviously important and valuable new use with bemused vagueness. If it was not industrial drafting, it could not be important.

I also used the word serendipitous to describe the completely unforeseen application of positive-working, deep-grained, anodized aluminum, factory-coated lithographic printing plates for direct plating from hand-made fine art on Mylar drafting film. In fact, Mr. Les Lawson, the technical genius who developed the most tonally responsive plate of them all, the Alympic Gold plate made by Howson-Algraphy, Ltd., of England, told me that he had had no idea of such a possible use during its development in his labs.

The plate was developed for continuous-tone commercial printing of a type reasonably common in Europe but rarely attempted in the U.S.; it prints with no little half-tone dots but with veils of color. The marvelous ability of this plate to read continuous veils of color from Mylar pencil toning, graphite rubbing, washes, and fine sprays is truly remarkable. Other excellent positive-working printing plates, mostly manufactured abroad, are also used in fine-art Mylar lithography. A true, mature medium of very high quality at both ends of its technical process

has emerged. This is serendipity at its purest. That is, serendipity squared.

The plates are the central secret of all Mylar-method lithography. Images of any genesis must be prepared with the plate's tonal sensitivities matched to what will be contacted to it in the platemaker. As luck, modern technology, and serendipity arranged it, the Mylar-working printmaker can do this with ease.

MAKING THE PLATE

To convert your Mylar art into a press-ready lithographic printing plate, you must have access to two pieces of equipment. The vacuum-frame platemaker will push your art face down against an appropriate printing plate under strong vacuum pressure. This ensures that every tiniest opaque dot will be forced as flat as possible against an equal area of the plate emulsion directly beneath it. The second necessary piece of equipment is a powerful source of light, strong in the ultraviolet band of the spectrum, which will blaze an even bath of its light across the whole area of the vacuum frame. The light penetrates through the plate glass of the frame, on down through the translucent Mylar or other image material and, where not blocked by each dot, line, and tone of the art image, gradually weakens the chemical bonds of the plate's polymer coating.

The plate areas thus affected by the action of the

light become soluble in the alkaline developer solution which will later be used, during the plate's development, to lift and flush all non-image areas away.

The areas of the plate thus cleared of image emulsion will be grease-repellent when wet, while the dots and lines of the plate's polymer emulsion protected from light by your drawing have a great chemical affinity to the grease-based inks used in lithographic printing.

The precise number of minutes and seconds a particular light source is permitted to shine on the plate surface determines the accuracy of the transfer of your drawing to the plate. Some commercial UV plate-burning lights are extremely powerful and will burn the usual commercial plate images in seconds. I quickly came to feel that these intense lights were too strong, and that the brief exposure times set on the timers of commercial plate-making machines were too short and inflexible for truly sensitive Mylar drawing quality.

I designed a very simple platemaking setup for my own shop, Atelier North Star, which years of comparison with many commercial platemakers gives me no reason to abandon. My light source is slow and soft and gives the plate an even, nondirectional bath of light from all directions rather than from a single powerful light source. My vacuum frame is home built, with only the small vacuum pump, the rubber blanket and seal, and the tubing as manufactured items. The frame and blanket were assembled for a total of about 450 dollars plus some hand labor. They replace a commercial rig that would cost up to ten times that sum.

For those interested in creating an inexpensive platemaking setup like this, I have included several photographs, and a diagram on page 43. The famous shop of George C. Miller and Sons, New York, now uses an identical light source over a simple vacuum frame manufactured by the NuArc Corporation. And as of this writing, a major West Coast commercial printer has decided to construct a soft light source of the same type in order to improve the quality of the shop's Mylar platemaking.

Still, if you use my suggestions, almost any commercial print shop which can handle a plate size to accommodate your art and paper size can make your first serviceable printing plates on their normal equipment.

First I will describe the general procedure for making any positive-working plate. Later I will discuss the various types and the specific supplies required for their development, protection, and storage, and a few special techniques for their use.

Positioning the Art on the Plate

One aspect of the problem of accurate color printing is the accurate positioning of the art on the plate when preparing to burn the image. It may sometimes be necessary to remove the Mylar art during this stage, and it is imperative that you be able to reposition it with microscopic accuracy. The only way that can be done with certainty is with the use of register pins. Therefore, I am going to describe this whole platemaking procedure with the use of register pins.

Hand-drawn register crosses on each sheet of your art can and should be used, for they are quite useful in registering the colors to each other during proofing on the press, but they are of no value in finding the position of the art on the plate in the vacuum frame.

The method I describe may seem a bit involved, but it will provide not only great accuracy but also maximum flexibility under whatever conditions you arrange for your art to be plated and printed. It does not require a commercial pinhole punch machine, or even a simply constructed home-built one like the one shown in the photographs. All you need is a simple office-type single-hole hand punch.

Later, as you gain familiarity with its workings, you may find it possible to simplify the several steps of this process; but starting right now, you will not ever find yourself trapped in a conceptual problem if you should be forced to change presses, or even to change print shops, in the middle of an edition. Such things occasionally become necessary, due to equipment breakdown, or scheduling problems, or even argument. But no matter how your art is to be

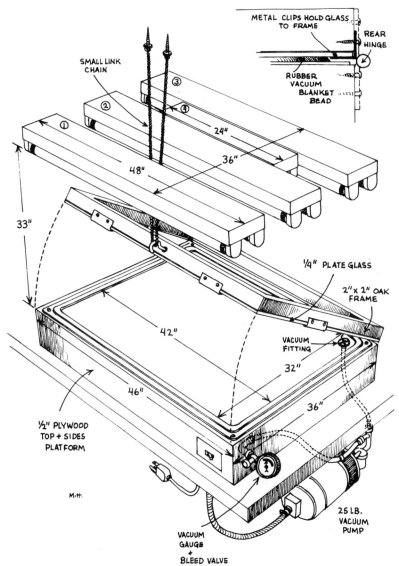

METAL CLIPS HOLD GLASS TO FRAME

REAR HINGE

RUBBER VACUUM BLANKET BEAD

SMALL LINK CHAIN

① ② ③ ④

48"

24"

36"

33"

46"

42"

32"

36"

¼" PLATE GLASS

2" x 2" OAK FRAME

VACUUM FITTING

½" PLYWOOD TOP + SIDES PLATFORM

M.H.

VACUUM GAUGE + BLEED VALVE

25 LB. VACUUM PUMP

A DESIGN FOR A HOME-BUILT PLATEMAKER
Vacuum Frame and UV Light Assembly

The diagram explains all the basic construction for a platemaking rig exactly like that developed by the author for his shop and also later placed in daily use at George C. Miller & Son, in New York. This version will accommodate any plate up to twenty-eight by forty inches. The plywood platform provides a base for the purchased rubber vacuum blanket. The two-inch oak frame is sufficiently rigid to carry the large quarter-inch plate glass. Since the frame is not counterweighted in this design, the hanging chain must be sturdy and well anchored above.

The light fixtures are fast-start, high-output fluorescents taking forty-eight-inch bulbs. The special bulbs are Sylvania F40T12SDB-65 Watt, with a medium bi-pin base. The twenty-four-inch bulbs for the smaller safe-light fixture are golden yellow, and can be left on without affecting the plate or the times of the burns.

Since the plate burns are for varying times from seconds to many minutes, a timer-switch should be integrated into the circuit to prevent accidental overburning.

This style of platemaker is old-fashioned, but its face-up design allows for "dodging" of areas of the image during the burn to vary the amount of light reaching them, just as a photo printer would, and the low-wattage lights allow a delicacy of control very valuable to Mylar work. The whole assembly can be put together in a home shop for a tiny fraction of the cost of commercial machines which are not as effective for this use.

printed, you will have all the register reference points to convert to any new situation.

You have at hand the ruled-out Mylar image guide sheet which was described on page 35, and that is used for relating the accurate positioning of each new color drawing over all the others. It is also to be used for establishing the correct position of the image on the edition paper, the untrimmed and trimmed dimensions and placement of which have also been ruled on this sheet. This image guide sheet was punched along its top edge, above the top of your drawing image, as were all the other Mylars used for the key and all the additional color drawings.

At that time, there was no assumption made as to which type or size of printing press would eventually be used to print the edition. All the drawings for all the colors were simply positioned perfectly to each other, and to the edition paper.

It is now necessary to develop a similar positioning system so that all the color drawings can be perfectly positioned on each printing plate before burning the image, in such fashion that each plate can then be fitted into its intended press so accurately that each color will be laid down on the sheet in perfect register. The plates must always go into the press just exactly in the same mounting position as do all the others. And the paper must pass through the press, over and over again, once or twice for each color, always in the exact same position on each pass. Therefore, the art on each plate must be perfectly positioned on the plate's surface at the time the image is burned.

Since the plate size is determined by whichever press has been chosen for the editioning, a new Mylar plate-guide positioning sheet must be made. The method described is based on the assumption that there is no big punch machine in use in the printshop you have chosen. Most commercial printers have such a punch, but many hand printers in stone shops do not. The shortcuts such a machine will provide you will be obvious at the end.

Ask the printer to cut you a two-inch strip from a discarded plate from the same press. This should be cut off parallel to the plate's gripper edge, but from an unbent and unpunched area of the plate. Two razor blade cuts along a steel straightedge, and careful bending, will do this in two minutes.

Cut a new sheet of Mylar the same dimension as the plate, and flop it face down. Tape the metal strip, also face down, so that one edge aligns along the Mylar's edge planned for the gripper side of the art. Now flop the Mylar, working face up.

Locate the point one-half inch in along the center of this edge and make a small pencil cross. Do the same at points one-half inch in and two-thirds of the way out toward the sheet's side edges. Take your hand punch and, looking down in the little well of the punch hole, center each cross and squeeze firmly. Your punch will easily cut through both sheet and plate, giving you three precisely matched pin-register holes in both.

With the assistance of your printer, rule in the position of the paper gripper line on the working face of the Mylar, as though it were the image face of the plate. Then rule in the position of the perimeter of the sheet of your edition paper, as it relates to the plate in the press. Each press will have its set of mechanical determinants which the printer will interpret for you. Now you have a plate guide-sheet which has one ruled-out reference in common with your image guide-sheet: that of the paper position.

Next, remove the metal strip and set it aside. Slip your image guide-sheet, also face up, beneath the plate guide-sheet so that the paper-perimeter rulings come into perfect alignment. Tape them together, and after taping recheck the register. Cut three one-inch squares from the plate guide-sheet over the three pinholes in the image guide-sheet. Slip register pins in the image guide-sheet holes. With clear tape, securely tape down three one-and-a-half-inch squares of Mylar, punched so that their holes fit over the pins.

You now have your image guide-sheet related to your plate guide-sheet and also to the punched edge-strip of plate. Now place your first Mylar drawing on these pins, face up. If its edge along the plate gripper side is not long enough to overlay the other set of pin holes, cut and securely clear-tape a piece of Mylar to extend it. Trim this new edge to cor-

respond with that of the plate guide-sheet, and cut three one-inch squares over the pinholes. Put three additional pins in place in the plate guide-sheet gripper edge, and tape in three new one-and-a-half-inch punched-Mylar squares. Your first Mylar drawing is now pin registered with everything.

At this point, I must ask for especially close attention to a discussion of the difference between any offset press and any direct press, whether hand or machine powered. An offset press presses the inked image on the plate surface against a rubber blanket stretched around a large steel cylinder, thus transferring the image, face to face, to the rubber blanket. This reverses the reading of the image, as in a mirror. If you have type or numbers in the image, they will now read backwards on the blanket.

The blanket is then turned on its cylinder and pressed against the paper, face to face, as it passes through the press. The image is again reversed from side to side, as in a mirror, and all details of it now read exactly as the image appeared on the plate.

This means that the image on the *plate* must be "right-reading" in any offset press. Right-reading is a printer's phrase you will hear often, and it pays to have its meaning crystal clear in your mind. Its application to the plate image in offset printing means that your art must be drawn wrong-reading.

When your art is plated, it must be face down against the plate in order to allow no space for the burning light to creep under the edges of each tiny dot and line. Even the few thousandths of an inch of the Mylar's thickness is sufficient to greatly degrade the sharpness and printability of an image if the art is plated face up.

Artists have always felt that one of the most difficult problems they had to contend with in making stone lithographs was that the image had to be drawn backwards, since the stone pressed face to face against the paper during the printing. A stone is a bit heavy and opaque, and a mirror was the only means by which the work could be viewed as it progressed. Not very satisfactory. However, Mylar is neither heavy nor opaque. If the preliminary layout sketch is drawn normally, and flopped face down under the Mylar sheet on which your real image is drawn, it is plainly visible as a reversed image. Furthermore, your final drawing can be flopped in a second, to view the emerging image in either perspective.

I have seen scores of artists adapt to this method in just a few minutes, once they saw it for themselves.

But supposing you have drawn your art with the image not reversed, planning to print it on a direct press. In that event, you can reverse it by taking it to a good film processing house of the type that makes color separations for large commercial printers. What you need from them is a film positive, of the type called a "dupe." This is made on a special film, without the intervention of a film negative. The emulsion side of this film is put directly against the image side of your Mylar in a vacuum frame and exposed to light just long enough to capture the same tonal values as your art. The technician who does this for you will be used to using clear film with image on it, rather than your translucent Mylar, for such work. And the images he is used to duping will have been composed of hard black dots and lines, not your gray, somewhat less than opaque pencil pigments. However, if your work is well drawn, and your Mylar clean, he can make you a virtually perfect dupe. He may need two or three tries to establish the correct exposure times for his burn, under his light source, but it can be beautifully done.

You now have your image turned both ways, and can print anywhere. But it would be best to examine how you would print your work offset, with your Mylars properly set up for that press. There are many more offset-equipped printers in your region than printers who operate either machine- or hand-powered direct presses. At this point, you have now pin-registered your first drawing to both guide sheets, and to a strip of plate which, when it is face up, has its holes aligned with all the Mylars. This metal strip is the guide by which all the plates will be punched.

Working under yellow or red light in an area protected from either daylight or artificial light, remove a plate from its protective packing and lay it face down on a table lined with paper to prevent

scratching the emulsion surface. Safe light is easily set up by using common yellow bug bulbs in any socket, or yellow fluorescent tubes available from any lighting supplier.

Tape the punched plate strip along the edge of the plate which will correspond to the paper-gripper line on your plate guide-sheet, turning it face up with the holes toward the plate edge. Flop the plate. With your hand punch, slightly squeezed, feel carefully along until the pin of the punch fits into each hole in the metal strip below. Be patient, until you are sure of the punch's position, then squeeze firmly. Remove the strip and mark it OFFSET on its face, and DIRECT on its back, along with the name of your edition, then store it in a safe place.

You now can instantly position and register your Mylar art to this plate at any time. Each color drawing for the edition will be set up to its plate in the same way. And each can be instantly positioned on any of the other plates, for checking the positions of colors or subtractive double burns for certain special effects, where one color can be used as a burnout mask for another. You will discover lots of virtuoso tricks like that, once you get your feet wet.

Even for the simplest printing procedure, whereby your image is drawn right-reading and plated for a hand-powered direct flatbed press like my own, as shown in the photographs in this book, the pin system above is used in the same way. The whole explanation has been designed to equip you to prepare your art without knowledge of where or how it will be printed. I felt that if I gave the simple procedure only, quite a few readers, having no certain access to a Mylar-experienced printer and press, would never start a project. That would indeed be a shame and a waste. When a first or second Mylar drawing begins to emerge in its true beauty, then for many artists the urge to go out and find a place to print it will grow irresistible.

Most offset presses have clamp systems and reference points for mounting plates which insure that every plate goes into the press in precisely the same position. This speeds proofing and overall accuracy. If you plan to print your edition on a hand press, and if your image is in several colors which register

closely to each other, you will require some sort of register control on the press.

In my opinion, the old ways of accomplishing this, such as using needles to fish through the back side of the sheet to find little needlepoint gouges in the margins of each plate, are simply not up to what the artist can convey with proper tools. Your color Mylars may all be perfectly positioned on each plate, but both the plate and paper, which contact each other on this type of press, must be repeatedly positioned perfectly, or much hard physical labor of printing, and many sheets of expensive paper, will be wasted.

The necessary equipment and its step-by-step use are dealt with at length in the section dealing with hand-press Mylar printing techniques beginning on page 72. If you study those procedures, and their relation to the offset techniques outlined above, you can then set color registration aside as a mechanical adjustment problem only, and henceforth feel free to concentrate on more important matters such as art, image, color, and the pleasure of creating truly beautiful original prints.

MAKING THE PLATE BURN

"Burn" is jargon for exposing the plate to ultraviolet (UV) light for carefully timed periods. In order to find out how much exposure time a given type of plate needs *under their particular UV light source* at its customary distance from the plate, commercial printers use small test film strips of various kinds put out by Kodak, DuPont, GAF, and other film manufacturers. These strips are usually on thin clear film base and contain little graduated patches of gray-tone image, ranging from nearly clear to solid black.

They are indispensable test tools for commercial half-tone printing but mostly a pain in the neck for Mylar work for several reasons. They are thinner than the Mylar used for drawing, and they have a clear base, not a translucent one as does Mylar drafting film. As a result, a 50 percent tone patch

on the test strip and a hypothetical tone patch printed on the matte side of a sheet of Mylar would yield completely different results on the plate, even if burned side by side under the same conditions. The light impedance is greatly different between the two. Taping the test strip under a piece of Mylar and then burning also does not duplicate Mylar work; doing that nearly doubles the light absorption by doubling the thickness of the film base and the matte Mylar surface has been raised away from and above the actual image on the test patch, changing its plating characteristics noticeably.

This sounds pretty technical and so it is, but you do not need to involve yourself beyond this point. The information gives you some ammunition to insist to the printer that your own work provides the best test for what burn time and techniques on a given plate will produce the best results.

Matte Mylar has other characteristics that make insisting on its use for such tests, especially where the printer may be inexperienced with this new way of making images on his equipment, the best thing to do. Our matte Mylar drafting film is not fully transparent. Its grainy, highly diffusing surface will reflect back some of the light passing through and greatly breaks up and changes the angles at which light rays passing through the matte undersurface reach the plate. This means that a given black dot of image on a matte Mylar surface will need a slightly longer burn time than will an exactly similar dot on clear film. It will also need a second small increment of increased burn time to remove the faint gray plate tone image left on the extremely sensitive positive plates by the impedance pattern of the Mylar matte surface itself.

Bear in mind two other general conditions. First, remember that the Mylar surface is grained and thus has minute peaks and valleys on which your art has been topographically deposited. Not every dot is on a little hilltop, jammed flat against the smooth plate; some are down in the valleys, and when the art is face down against the plate these are raised slightly away from the surface, permitting a tiny undercutting of the dot's image by the diffused light.

Second, the drawing's dots are not pure 100 percent black opaque pigment. Use a powerful magnifier or printer's loupe and inspect your drawing on the light box. You will see that it is a translucent dark gray. Some light can get through even the deepest tones of any drawn image.

Therefore two conflicting conditions are at work. You must burn longer to compensate for the matte surface's impedance to light and at the same time be careful not to burn through the translucent and only partly contacted image. As the creating artist, you should anticipate these effects and draw your image with nice strong dots, using good pigments.

Tentative, overly pale drawing gets progressively more tricky to plate effectively, whereas a well-drawn image can be lightened and made more delicate umpteen ways — by changing burn times, masking, double-burning, special plate-development, and by the alteration techniques possible for use on the finished plate.

I'm not intending to scare you off with all these qualifications. By the standards known to old-style stone lithography on the one hand and those known to the very finest commercial printing houses on the other, positive little miracles are occurring here, right under your hand, by your using these techniques. But not every shop or every printer has seen this work handled well, and you must have at least a general understanding of the technical process to explain, request, and defend what you want from the printer. If he has not already done a good deal of printing from original Mylar drawings, let him read this. It will help; it may help even if he has.

With your Mylar art registered in position on the plate, close the glass vacuum frame and turn on the vacuum pump. Pull vacuum to between twenty and twenty-five pounds on the gauge. Wait. And wait some more. This work always hovers on the very margin of the plate's capacity to read it clearly, so give vacuum every extended chance to make the best possible contact. When using clear film or red Rubylith sheets, you will notice the very slow moving-about of tiny air pockets under the sheet and the slow formation of moiré patterns. It sometimes takes many minutes for this movement to gradually cease and the patterns to become uniform. Until they do,

there is not perfect contact by our very stiff standards. Matte Mylar does not show this movement and the moiré patterns, but air exhaustion under its surface is equally slow, so be patient.

Also, remember that every piece of dust, lint, or eraser detritus will make a "hickey" on the plate. If the hickey is in an area clear of image, it can be cleaned from the plate later, with image remover and a cuss word. If, however, it is in an important toned area, it may well ruin the plate image altogether and you may have to plate again, at some expense.

This happens to everybody sometimes, but the chances can be greatly reduced by scrupulous cleaning of both sides of the glass vacuum frame, cleaning both sides of the Mylar carefully before insertion into the frame, and a slow brushing off of the plate surface followed by much inspection under vacuum before burning. In a dirty shop you may have to open the frame twenty times before you get everything shipshape. Do it. And then clean up the platemaking area.

Photography shops sell pressure cans of dust remover and antistatic sprays. They help. And there are static dust collectors of many types available. Use them.

Testing for Burning Time

To test for best burning time, make and tape down on the *back* of your drawing a special overlay mask that will expose only, for example, a 1" × 6" strip of the most important area of your most important drawing image. Make a series of test burns by moving the art in close steps across the surface of the plate, using scraps of opaque Rubylith, black paper, or printer's "goldenrod" yellow paper to cover all the plate at each test burn, except for that little strip of your image.

If you are working at a shop where they routinely make commercial printing plates, ask the standard exposure time they give to any positive plate in their equipment. Start the exposures for your first test plate at 50 percent lower than their time and increase it for each new test strip by 10 percent so that the tenth test will be at 150 percent of their standard.

Make careful notes of your steps and positions on the plate so you can understand results later.

This is a gross test, designed to find the upper and lower limits of acceptable exposures for your material, on your type of plate, on that particular platemaking rig. But if you are trying this in a shop with no such positive platemaking experience or in a duplicate of my unusual rig diagrammed in this book, start with test strips of your art at a half minute, then one minute, two minutes, three minutes, four minutes, and so on up to ten minutes. The burn times under my soft lights are longer than those in commercial platemakers. Under any light, you will find a lowest and highest value within which the general appearance of your image is worth considering.

Each manufacturer provides a developer solution formulated for its own plates. In some cases these developers may work on other brands of plates, but you must experiment for yourself to see whether you like the results.

Develop your first test plate by hand under the same yellow safe light (made from yellow bug bulbs or yellow fluorescent tubes) as that described earlier. Use a developer's hand pad, available from the plate supplier or any printers' supply house. Use lined-rubber kitchen gloves to protect your hands. The developing solutions I will recommend are not particularly odorous or dangerous, but they are caustic and best kept off your skin. For larger plates, pour just enough developer on the pad to get it softened and saturated. Quickly pour a puddle of developer onto the center of the plate, sufficient to permit quick, complete coverage of the whole surface by wide, swirling passes of the pad. This should be done boldly but lightly, evenly but copiously: pressure on the plate will not speed development, and always risks scratches. Move the pad back and forth and up and down, then all around the edges. Try to keep most of the developer on the plate. Whatever gets pushed off is wasted.

At the end of two minutes, squeegee off the plate in even, light strokes with a twelve- to eighteen-inch windowwasher's squeegee. Also squeegee the pad

to get most of the tired developer out of its material. Repeat the whole sequence again immediately, paying special attention to any area that appears less than perfectly developed. If your developing solution stops discoloring and you see no noticeable changes taking place, you're finished. The whole development cycle should have taken four minutes or less.

Hose off the plate thoroughly. Lift the plate by one near corner in a slow, steady motion. This will prevent kinking the thin metal. Kinking must be avoided, especially in any image area. Hose down the back of the plate, the flat sink surface beneath it, and the squeegee to flush away all traces of developer. Do not wash the pad.

Since this plate has been for test purposes only, there is no need to gum and preserve it unless you want to see it inked and printed. You probably won't.

Now you can read the test strips. First, with a printer's loupe examine your original drawing on the light box or table. In the area which appears in the test strip, examine the part which has the lightest true tones, comparing your impression of the *size* of the same tiny dots in that area of the plate. Remember that the plate dots, not being black, will be very much lighter in color. They look much less contrasty to the eye, but they can be read for size. Under the loupe's magnification, check the nonimage areas around the dots to be sure they are clear of any residue of the color of the emulsion which makes up the plate's image dots.

Next, compare the darkest, most nearly (but not quite) solid area of your drawing with the dots in the same area on the plate. You will quickly see which test exposure is just a bit too light or over-burned, and which is just a bit too heavy and filled-in, or underburned. If for some reason *all* your tests are too light or too heavy, immediately carry out another test group, setting exposure times on a wide enough span above or below those of the first test to establish the needed parameters. However, the odds are that you have successfully bracketed the optimum time on your first plate. You should now be ready to make another test plate, using the just-overburned and just-underburned exposure times

as the upper and lower time limits of your second test series. Divide the difference into whatever number of equally spaced lengthening times seems practical to give you useful information. When developed, this second test plate should tell you everything you need to know to make your first printing plate ready for the press. Transfer your notes by marking the burn times for each strip right on the plate next to each, and store the plates for later reference.

Remove the mask from your drawing. Make any last-minute checks or cleanups on your Mylar art. Punch a new plate, and burn it at your best test time.

Making the Plate Press-ready

When you have developed the plate, any deletions or cleanups are best carried out right in the developing sink.

The plate's image development is now complete. From this point on, the plate can be handled in ordinary light, providing the image areas have no further contact with any alkaline materials. All daylight and the usual types of artificial lighting contain some ultraviolet radiation, and the plates are, to some degree, sensitive to wavelengths in the white blend of the spectrum as well. Therefore, any later contact with significantly alkaline materials, especially in the presence of moisture, will cause the plate's image to be weakened and the emulsion softened. The abrasion of printing, especially under the immense pressures of the hand press, will cause the plate to fade prematurely. Consequently, care will be taken that all the press chemicals will be either acid neutral or slightly acidic.

For removing hickeys, smudges, plate tone, or unwanted image areas, each plate manufacturer provides a recommended chemical remover, usually a liquid in small bottles. Some of these have terribly corrosive fumes, and some are runny. (**Be sure the area is well ventilated with all these chemicals, and wearing a small mask is recommended!**) For most purposes, I like the Howson-Algraphy Pos-idel, which is a controllable gel with much less aroma than others and does not run or creep. This

gel remover works on the plates of its manufacturer, of course, but it also performs well on other brands of positive plates, as does the Polychrome liquid remover.

Before applying the image remover, make sure the area around the intended correction is blotted dry, to prevent the material from bleeding and dissolving into surface moisture capable of conducting it to other emulsion areas. Apply the remover with a cotton swab or watercolor brush to dry areas of the plate. Work it in with the applicator until you see all trace of the area disappear. Then, with the bucket of water and several sponges of various sizes you have kept nearby as standard equipment for this job, take a damp sponge and carefully pick up the remover, being mighty careful not to move into any area you want to keep. Squish out the sponge thoroughly in the bucket. Squeeze it to damp, and again carefully clean the precise area. Squish out the sponge again, and this time do not squeeze it to damp. Now go over the whole region of the plate very rapidly with a drenched sponge, moving and flushing away all traces of the remover so quickly that there is no chance for it to attack other areas. If you have additional removing to do, use absorbent paper towels (of which I find Bounty to be best for absorbency, strength, and freedom from lint) to sop up all water, until the plate is dry enough to work again. This remover is fiercely effective, and you must work with precise routine and care.

For use on its two types of positive plates, the Spartan and the Alympic Gold, of which more later, Howson-Algraphy provides a marvelous liquid called Image Reducer. If a certain area of image on the plate needs to be made less strong, less intense, to set it back in visual perspective, Image Reducer is applied at this stage or later on the press. The liquid accomplishes this by very gradually removing the upper layers of emulsion on each dot, but not reducing their diameters, until the emulsion reaches the level of the top of the peaks of the plate grain. Steady gentle rubbing with the solution on a pad gradually lightens the image, and that is how it will accept ink. I have successfully modified Howson-Algraphy Image Reducer by diluting it with water to slow its action still further, and by mixing it with Howson's Posidev and Screenless Developer to accelerate its action a bit. However, it is not intended for use on other brands of plates.

When you have completed your cleanup and corrections, sponge off the plate one last time and move it, quite wet, to a nearby table that has been covered with newsprint or brown paper. Form a pad of five or six Bounty-type towels or Kim-wipes with which to coat and buff the plate with a gumming solution, which will protect the surface from abrasion and atmospheric degradation. There are many solutions on the market; for this first protective gumming, however, I use Polychrome's excellent plate gum on their plates, and Howson's Kleergum on all the others. Kleergum is a mixture of gums and white asphaltum, and is really a quite remarkable primer and preserver combined. With the plate quite wet, shake the bottle well, and pour out a puddle four or five inches in diameter—enough to protect an average plate. Then with the pad, quickly work the gum over the wet plate surface, making big wide sweeps from edge to edge and then from top to bottom. Turn the pad to the fresh side and continue buffing the plate surface. Use a fresh second pad to complete the "buffing down tight" of the gum. Dry off the plate back.

Your first-ever Mylar-method lithographic plate is ready for the press or for storage for a reasonable time prior to printing.

Some Comments on Plates

Howson-Algraphy Spartan plates are reasonably inexpensive, and are passable for use with ordinary pencil images. Fuji and Polychrome top-of-the-line positives are superb for penciling, sprays, and almost all images except washes and rubbings. Their quality control and uniformity are excellent.

Howson-Algraphy Alympic Gold positive plates are different from others. Other positive plates are essentially only able to "see" and provide imagery composed of solid areas and clear areas, or what could be called a "yes-no" capacity, with no ability to see and render a "maybe." But Alympic Golds, while also able to render a yes-no image—if that

is the nature of the art contacted to—can also reproduce a continuous veil of image, such as is laid down by a dilute wash. To get such an image from them successfully, they must be carefully controlled for time of exposure, time of development, and the temperature of the developer. Even the faint shadowing caused by the grain of the textured surface of matte Mylar will cause a background tint to suffuse the whole image if these three conditions are not held to optimum values. This tinting can often be an asset, and can be planned for in advance. It also can be removed by a slightly longer burn time, but to do this you must plan your art to be a little stronger and more contrasty than it would need to be were there no background tone from the surface grain. Also, it can be removed from large parts of your images by double-burning the plate, using a specially made mask which just covers and very slightly overlaps the actual image areas you wish to retain. Often, a combination of these techniques will give you an extraordinary plate—clean, printable, and, in terms of what printmakers could accomplish by older techniques, absolutely mind-blowing.

The Howson Alympic Gold plate behaves much more like film than others in the sense that the longer it is exposed, the more it reacts to the light's effect. That is the "maybe" capacity at work. And the longer it is bathed with developer, the more the otherwise correctly exposed image will be lightened and made less contrasty. The plate's anodized grained surface can yield random dot printing tones as fine as an average of 250,000 dots per square inch. Once you understand this action, you will have a clear idea of just how marvelous a working tool for the printmaking artist these plates really are, and how to take advantage of their unique capacities.

Mylar art laid down by washes, graphite rubbing, fine sprays, superfine drawings with hard leads, Stabilo #8008 china marker pencil pigment which has then been dissolved and softened with a wet brush, or combinations of these applications can only be plated on Howson Alympic Golds.

Howson's standard Posidev developer, made for line work on Spartan plates, can be used on the Alympic Gold, but their Screenless Developer is more sensitive and better suited to the Gold's deeper emulsion layer and deeper surface grain. It can be diluted with water to slow the development process further in order to gain control.

As Gold plates develop with hand and pad processing, the image quickly appears as the developer stains from clear to brown under the yellow safe light. A second bath of developer will discolor only a little. In my own experience, developing a Gold plate beyond five minutes will cause the plate to be less image-responsive on the press. The manufacturer recommends careful development timing, and a temperature of about 70 degrees.

With the Gold plates you may or may not encounter the following problem when developing images with rubbings, washes, and fine sprays. But I have, so I will describe it and its solution.

When these plates are developed by hand and not in the extremely expensive automatic processing machine designed for them by the manufacturer, the developer is at its most active the first instant it hits the emulsion.

On very delicate, thin imagery such as those types I listed above, if the developer is poured splotchily across such areas, it will instantly cause an irregular blotchy look in the image, which may not be possible to work out. This is caused by the fact that the developer is at its most active when purest, and is less effective each instant it is being contaminated by dissolving emulsion.

The cure for this is simple but will save your plate. Prepare about a quart of Screenless Developer in a wide-mouthed container and, with a motion you have practiced with water a number of times on another plate, flood the developer across the plate in one big wave; if your wave stops short, there will be a line. You will lose most of the quart and need to have more prepared in a second container to use as you continue normal development, but that is a lot cheaper than replating.

Still, all this said, Alympic Gold plates are in a class by themselves.

You may or may not need their special capacity to print continuous veils and washes of color, but if you choose to work with them you must be prepared

to deal with this plate's tendency to produce the Mylar sheet's impedance pattern as a barely perceptible plate tone. Masking your image areas greatly reduces this problem. I have sometimes accomplished this, when my art was straightforward penciling without continuous-tone veil areas, by using a dupe positive, burned "fatter" and more contrasty by a commercial film processing shop. Each tiny dot of my drawing appears black and slightly larger on the dupe. When it is meticulously pin registered, it can create a second "duotone" plate, as described earlier, but it can also serve as a perfect image mask on the original image plate, isolating and protecting each dot and permitting the tone between them to be burned away.

When you then burn the Alympic Gold plate, you make a soft, normal burn for your Mylar. There will be some plate tone visible, since this plate shows your image clearly even in the vacuum frame. Remove your Mylar original, put down the positive film mask, and make a second normal burn. If the film has been properly made and properly registered, when the plate is developed you will find your lovely soft drawing image on a clear background. This is simply astonishing to a stone printmaker.

Those of you who like to think about all kinds of ways to adapt and innovate will begin to see a thousand ways you can work with these materials and processes to achieve effects never before accomplished in printmaking.

During the press run, you will often find other tiny spots on the plate that need removal. Clean the plate of ink, using any common offset-plate wash worked on with clean rags or paper towels, and clean water and a sponge. Blot the plate dry and use the image remover as described earlier. It is possible to use the Howson Image Reducer on Howson Spartan and Gold plates at this stage, also. Occasionally you may find a flaw that requires an addition to be made to the plate image. Howson makes an Additive Tusche, a lacquerlike liquid which can be applied to small areas of the plate, provided that area of the plate has been scrupulously cleaned and degreased with an effective solvent and is thoroughly dry. To be permanent, the tusche should be baked dry under a heat lamp or electric hair dryer for up to half an hour.

Obviously, this is an emergency fix to save time and money. The best and most reliable way to make such a correction is to correct the Mylar, and quickly replate. This is a freedom no printmaker has ever had before, and it raises the value of this Mylar-method into a class all by itself.

By these procedures of image removal, image reducing, image redrawing and replating, all the cumbersome and unpredictable correction methods of stone lithography are entirely avoided and made to seem primitive by comparison.

PLATING FROM GRAINED PLATE GLASS DRAWINGS

All the general procedures of plating from Mylar art apply to plating from glass, except that allowances must be made for the thickness of the glass itself and its glassness, to coin a word.

First, when you have made your ruled-out Mylar guide sheet, use it to locate the position of your drawing-to-be on the matte side of the glass. Tape it down there. Then tape three register pins in place on the glass, using clear tape. During the preparation of all subsequent color drawings, whether they be on Mylar or on glass, this precise pin placement will keep everything in register.

Remember that you cannot accurately see down through a quarter-inch of glass to something underneath it without encountering parallax, a distortion in visual perspective. You will quickly learn how you must manipulate your guide sheet, and subsequent drawings, to keep registry.

Your plate-guide sheet, which will relate the glass to the plate pinholes, requires one extra step because you will have to remove the pins from the glass face before contacting it to the plate under vacuum. To do this, make a piece of Mylar that is punched to fit both the pins of the plate edge, and the pins of the glass. Position it on the glass, and tape it in

place with clear tape near the glass edge which lies nearest the punched plate edge. Cut away all the area of this sheet except for about an inch which overlaps this edge of the glass. Add tape all along to make it secure, and remove the pins taped to the glass. You now have the glass, with a piece of Mylar extending beyond it to the plate pin edge, with holes which conform to those of the plate. This sounds complicated, but it will take you about ten minutes to sort it all out the first time, and from then on you will find it routine.

The second problem of glass in the vacuum frame is its thickness. The quarter-inch is not too thick for the frame to be able to pull vacuum to all areas inside its outer bead seal, so that is no problem. However, the vacuum frame glass must not be asked to bend when under pressure. To prevent this, ask your local lumberyard or cabinet shop for scrap pieces of quarter-inch plywood. These odds and ends can be used to fill out most of the empty spaces around the perimeter of your various glass images, between it and the vacuum bead. You should have half a dozen which extend one inch or so short of the front-to-back dimension of the vacuum frame, and the same number for the side-to-side dimension, all of them about two or three inches in width. With a few other, smaller scraps, you should be able to level out the whole frame for almost any size piece of glass you work with. (I have also used blanks made from Fome-Cor and taped-together scraps of mat board. Anything a quarter-inch thick is fine.)

When you have registered your glass to the plate, position these smaller blanks all around it to mostly fill the working vacuum blanket area with material of equal thickness. Gaps of an inch or two between pieces will not stress the glass of the frame. When your plate-glass art is in place face down on the plate and the plywood-blank fillers have been fitted in around it, place a big clean sheet of Mylar or clear Kronar over everything within the vacuum-bead seal. The purpose of the sheet is to prevent any direct glass-to-glass contact under the high stresses of vacuum and to prevent the accidental intrusion of even one tiny grit particle between two such unyielding surfaces. The film sheet gives just enough cushion to prevent breakage. Kronar will not noticeably add to your necessary burn time, but the matte Mylar will cause a slight impedance and diffusion, which may require a slightly longer burn.

(I believe the above to be a perfectly safe procedure. In many vacuum drawdowns of glass set up in this manner, I have never had any problem, on my rig or anyone else's. Take notes on all you do; lessons learned on the first occasion will be of great value on the second.)

Later, when you remove the plate for development, you will see an indentation along every edge of the glass and blanks. If you have sanded the blanks' edges and Dermicel taped those of the glass, the bends will be rounded and slight, and are of no consequence. None of them will be near the image area.

To remove the images on the plate caused by all the Dermicel, tapes, and blanks, and also any plate tone from the glass, apply the usual masking double-burn techniques. They work fine.

One final note about this technique. Many vacuum frames long in use have glass tops with many scratches and other potential stress points already in them. You will find the average commercial printer will turn pale at the very mention of this whole technique, for he foresees the possible cracking of his frame glass. On one occasion, I promised a printer I would immediately get in the car and go fetch a new replacement for his glass (which was disgracefully covered with scratches anyway). Since he secretly had been putting off its replacement, he leaped at that. Of course it didn't break, and I thought he acted grumpy about it.

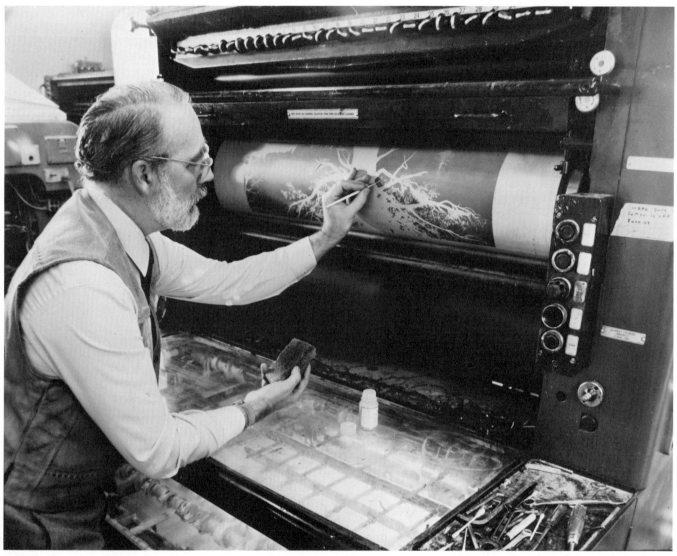

Figure 19. *The removal of a minor unwanted image detail on the plate used to run large pale flat sky color on artist's edition #101, Lucky Lady. The press is a forty-inch Heidelberg single-color, a superb printing instrument for such work.*

Figure 20. The print used as a demonstration in this book was drawn on hand-grained plate glass. Here the artist is in the process of graining a large piece of glass, using standard stone litho carborundum grit #180 (for a fairly rough, coarse surface grain structure) and a small litho stone as a grinder. The glass has been bedded on several soaked blotters on a large litho stone. A circular grinding pattern is visible in slurry on the surface. As slurry becomes clogged and sticky, it is hosed away and fresh carborundum is added. The whole process takes less than an hour.

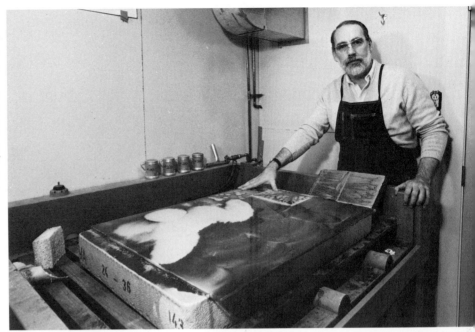

Figure 21. The first complete drawing on hand-grained plate glass, proofed and editioned on the Brand hand press at Atelier North Star in June, 1978. The working face of the glass is turned toward the camera, and the girl faces left on both the drawing and the final print. The printing plate made from the glass has the image reversed. The edition sheets are hung to dry on a clothespin rack similar to a billiards scorekeeper.

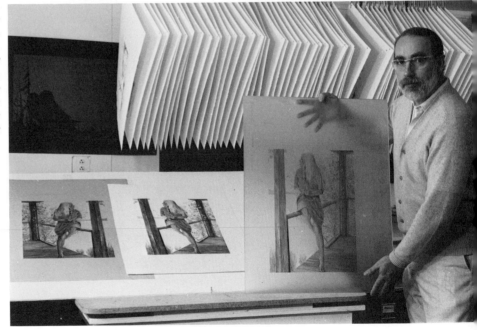

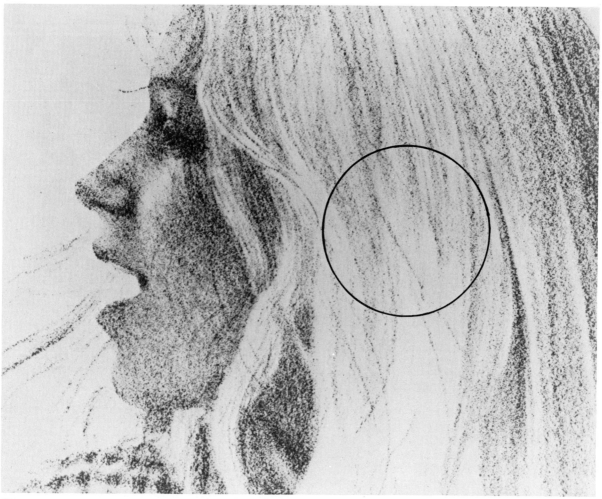

Figure 22. *A detail of the girl's head, much enlarged, shows the beautiful grain structure produced by #HB artist's lead pencil drawing on the glass surface. A moderately coarse grain was produced by grinding the glass surface with #180 Carborundum grit of the same type as used to grain stones. Grain structures can be made of any degree of coarseness or fineness by varying the fineness of the carborundum. The most extraordinary even velvety pencil toning can be readily achieved, using one or all of dozens of artist's pencils, pigment sticks, or washes, sprays or brushed-on solid areas of liquid inks, tusches, acrylics, and other opaque-to-light materials.*

All manner of solvents, liquid cleaners, and detergents can be used on the inert, tough glass surface. Erasures, removals, lightenings, and other alterations large and small can be repeatedly, routinely made as the work progresses. With due care, this face could have been removed and redrawn six times without altering the grain structure in the area or in any way affecting the surrounding image. Any artist who has made stone lithographs can appreciate the value of that freedom.

Throughout the edition, the individual hairs continued to print cleanly and fully. The circle represents the size of a dime in scale.

Figures 23 and 24. The plate glass demonstration print for this book was drawn on this very large homebuilt portable light box measuring thirty one by forty four by four and three quarter inches, yet weighing only fifty pounds. It has a carry-handle, fits nicely atop a tilting drawing table, and gives a very even, subdued illumination. Large air vents are necessary to prevent overheating of special bulbs (see pages 32 to 34). Several lengths of homebuilt T-bars rest on lip around box to prevent hands from touching and smudging work areas. Notice the easy readability of images when flopped.

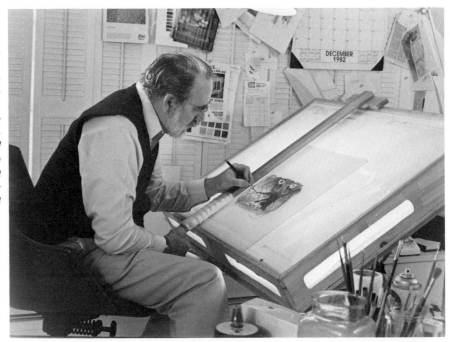

Figure 25. *Arranging filler pieces around plate-glass drawing to provide even surface for glass top of vacuum frame to rest against during burn.*

Figure 26A. Here the artist has partially completed a burnout mask to use to clean the non-image areas on the key drawing plate of any residual dirt spots, smudges or "plate tone" left on the clear areas of the plate after the main plate burn of the key drawing art. The artist is drawing and painting in this mask with opaque to cover and very slightly overlap each dot, line, and solid area of the key drawing beneath. When the image burn has been completed, the image art will be removed from the register pins inserted through the punched plate in the vacuum frame, and this mask will be registered in place for a second, longer burn. The developer will then easily clean the plate of all unwanted ink-receptive flaws.

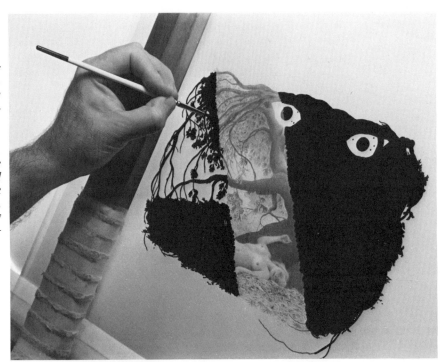

Figure 26B. Burnout mask for key drawing shown in Figure 26A does not precisely fit images of other color drawings. Several scraps of Rubylith are fitted over a tint color drawing on its separate plate to be given a second cleaning burn to clean the non-image areas. Any final few spots which may then remain near the image perimeters can be quickly removed on the developed plate with image remover and a tiny brush.

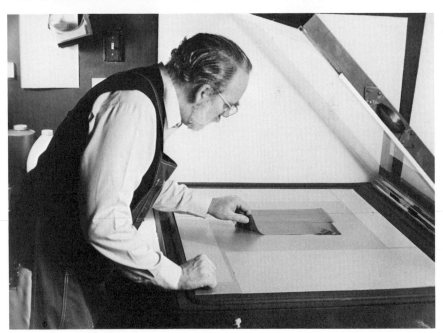

Figure 27. *Artist's compact platemaking room measures only ten by seven feet, yet contains large home-built vacuum frame and light source, developing sink, vent fans, and ample storage space for all materials needed to produce plates for any press up to thirty-by-fifty-inch capacity. Sink is made of one-inch plywood, heavily coated with industrial epoxy enamel.*

Swirling pattern which spreads developer evenly over plate is visible. Sink has four-foot flexible hose for flushing plates clean.

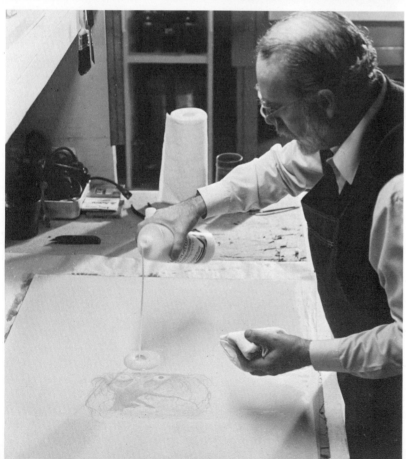

Figure 28. *Pouring Howson Kleergum solution on still-wet Alympic Gold plate to protect freshly developed image. Gum will be spread evenly, then rapidly buffed down dry with fresh pads.*

Figure 29. All sheets to be used for the edition printing are put through the press three times to eliminate paper stretch and distortion. The smooth back of a large discarded plate makes a perfect undersurface.

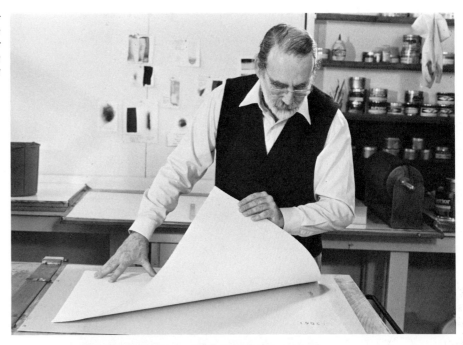

Figure 30. Punched plate is positioned on the hand press pin bar and securely taped down with 2-inch plastic tape. Image is covered with paper to shield it from any damage prior to rollup.

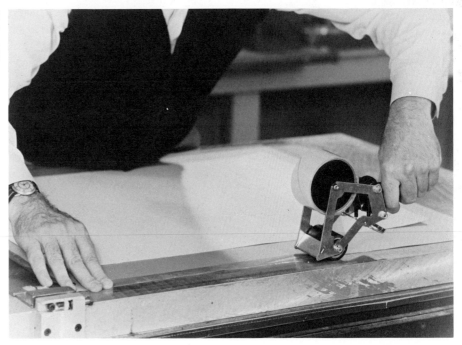

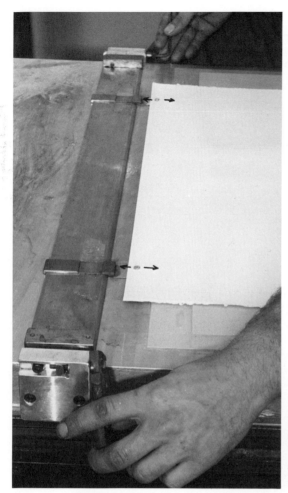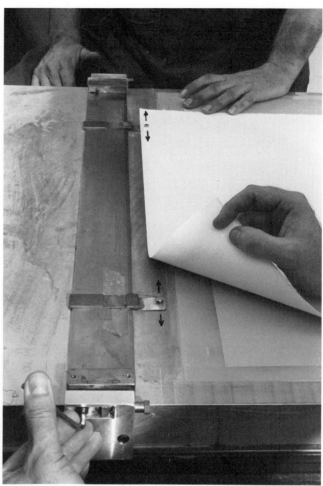

Figures 31 and 32. *The artist's design of his pin register bar, built from a sketch at a local machine shop. In Figure 31, the worm screws running parallel to the press bed axis adjust either end of the pin bar forward or back. In Figure 32, the worm screws running at right angles to the press-bed axis adjust the whole bar laterally. Combinations of these adjustments can bring the edition paper into perfect register with the plate, taped firmly to the press bed. In the rare cases where register must be so adjusted, the artist uses the punched translucent Mylar key drawing on the pins to see perfect alignment with the plate.*

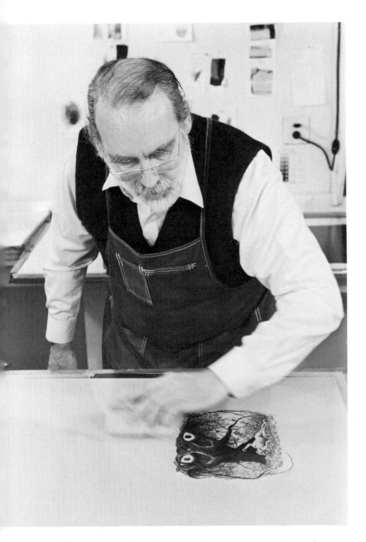

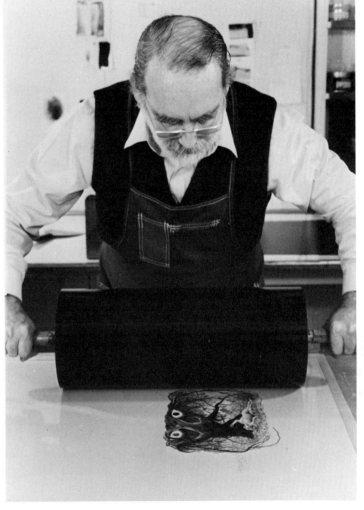

Figure 33. *Plate is sponged down copiously to dissolve and remove the protective gum. Excess moisture is picked up and an even dampness achieved by controlled sponging. Careful light frequent sponge passes will remove water droplets and streaks from an open-type image, but a rocker (see Figure 40) will be needed to do a perfect job on large solid flat images. After each ink rollup pattern, any transient ink specking or scumming in nonimage areas can be wiped away with the sponge.*

Figure 34. *Plate is inked up slowly in two or three alternating sponging and ink rollup patterns. No special rollup ink or other priming procedures are necessary if plate has been properly prepared. Sponge bucket contains two gallons of water with two ounces of standard offset fountain solution. All other additives tried by the artist to retard evaporation during the inking patterns have produced more problems than they solved. Experience with these plates on the press soon develops a rhythm of inking and sponging which works fine, especially with the use of the rocker, which hits the whole plate area at one time.*

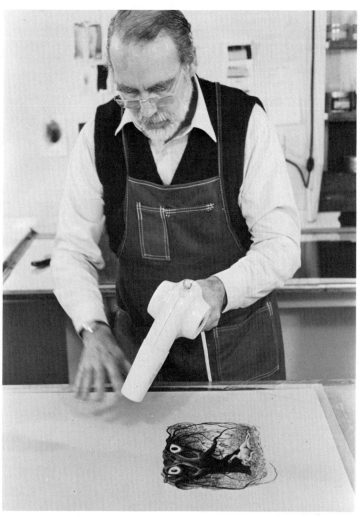

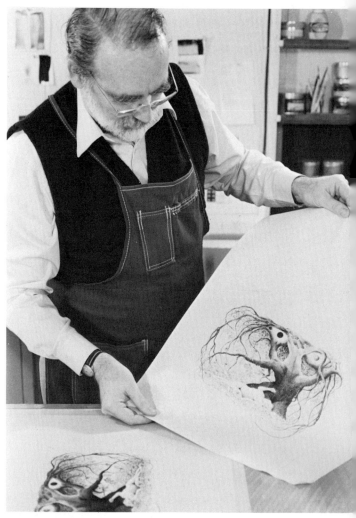

Figure 35. *Plate is inked ready for printing. Since best register is attained by dry printing, evaporation of all moisture trapped in the surface grain structure of nonimage areas can be speeded by use of a hand flapper-fan or an electric hair dryer.*

Figure 36. *One or two first impressions can be pulled on newsprint paper to check the image and set the ink on the plate emulsion. The image will appear light, as newsprint has poor ability to take up ink.*

Figure 37. *Each sheet of edition paper is fitted on the pin bar and gently laid down over the inked image, with the other hand holding the pin positions secure.*

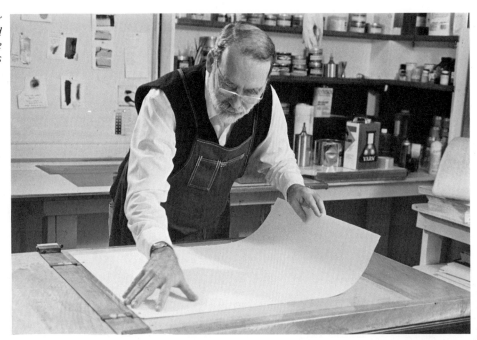

Figure 38. *Pressure is adjusted to give medium-to-strong pressure against the thicker edition paper in the press, and the first of the edition sheets is cranked through. The press's heavy-gauge Mylar tympan sheet removes need for additional boards or sheets over the edition paper.*

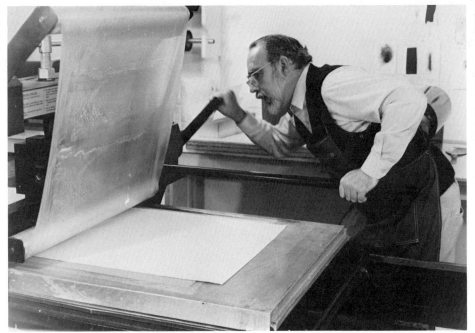

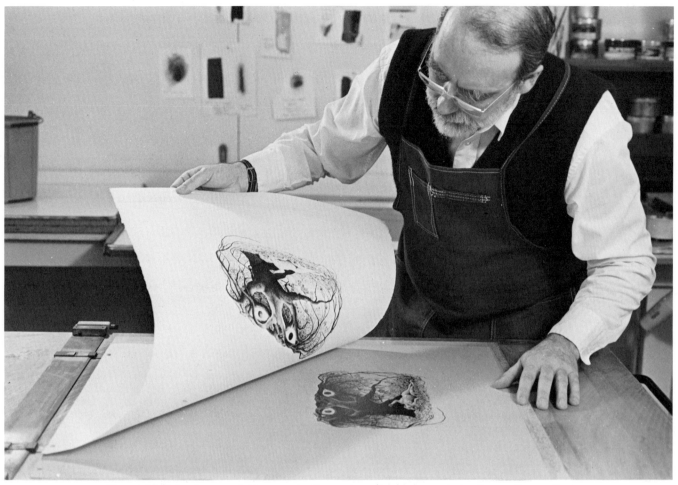

Figure 39. *It is always a thrill to see the first perfect print come up on the first try. Succeeding sheets will be hung in clothespin rack shown in Figure 15 for drying, and plate will be dampened for the next rollup of ink.*

Figures 40 and 41. *This homebuilt dampening "rocker" can actually be conceived as a section of a huge seamless roller. Open, variegated images can be evenly dampened preparatory to ink rollup by using only a squeezed-out sponge. However, any large solid area is extremely difficult to keep free of water droplets and sponge streaks which interfere with even ink rollup, just as in stone printing.*

To solve this longtime printer's problem, the artist designed this "rocker." The rocker is prepared for the printing by being sprayed repeatedly with a spray bottle of clear water and worked over by hand to achieve an even dampness. The plate is drenched by squeezing out a sopped sponge over the image, then rocking the rocker back and forth, applying light pressure only. This picks up the sponge water puddles and evens out the residual water trapped in the plate's grain structure. No moisture pattern will appear on the large flat image area. If the plate appears too wet, continue rocking action, which both absorbs moisture and fans more rapid evaporation. If plate appears too dry, apply more pressure on ends while rocking. This will deposit an even amount of extra moisture. Wet cotton sheeting will not disturb the ink on the image, or leave lint.

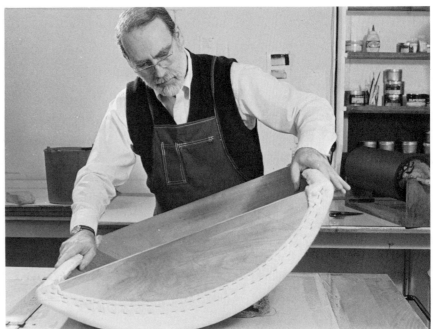

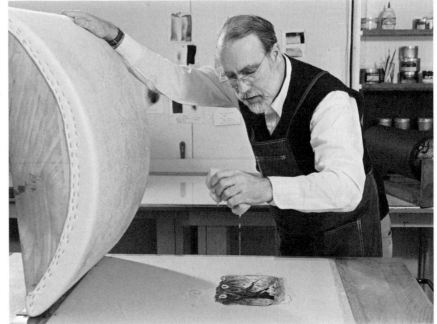

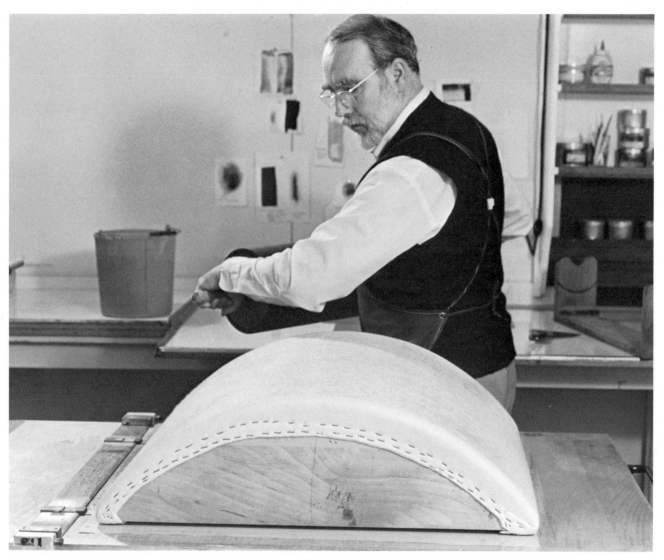

Figure 42. Evaporation of moisture from the plate can be greatly retarded by setting the rocker face up over the plate during recharging of the ink roller.

Figure 43. If flat space is at a premium near the press, rocker can be hung by its lip on a couple of large hooks, between impressions. Notice the specially constructed wood frame which carries ultraviolet-filtering clear Plexiglas to eliminate any degradation of the plate image during printing.

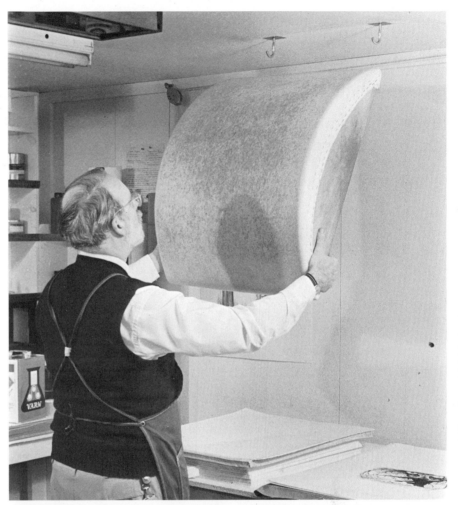

Figure 44. Much larger rocker (this one measures forty three by twenty six inches, and has an effective surface working area of twenty four by twenty six inches) can be constructed of quarter-inch plywood in monocoque design, with extensive cutouts to keep weight light enough for one-person use. The rocker is coated with several coats of waterproof epoxy and will last for years. Sheets of Mylar stapled to sides, and strip of foam tape around edges will give the same evaporation retardation as shown in Figure 42.

PRINTING

Your plate is ready to be put on the press, inked, and printed. There is no space to go through all the thousand little details of pressroom procedures; they would warrant a book of their own. The premise in this chapter is that Mylar-method printing is in general similar to all lithographic printing. This is especially true of any offset printing, whether the press is a flatbed type or a rotary machine.

AN OVERVIEW OF OFFSET

For those of you not yet familiar with the processes, here is an overview of offset printing in general.

Any offset press is designed to apply ink from inking rollers directly onto the plate. The plate is kept wet by a plate-dampening system so that ink will adhere only in the desired image area.

The inked plate then applies its impression under great pressure to the surface of a precision-made rubber blanket stretched around a large steel cylinder. This inked image, having been "offset" onto this compressible, dry blanket, is then impressed onto a dry sheet of paper.

The first designs of these presses were close derivatives of the flatbed stone "direct" presses built before and after the turn of this century. The first generation of change used a large, rubber-blanketed cylinder which carried the paper around one revolution, rolling it across the inked stone in the flat bed of the press.

The second generation evolved probably from ac-cidental operation of this press without a sheet of paper clinging to the big blanket cylinder. The inked image was, of course, transferred to the blanket. From this it was a simple step to redesign the press to roll this inked cylinder a little further along its track, so that it rolled over a sheet of paper held flat on an extension of the flat bed. Thus was born the flatbed offset press.

Versions of these second generation monsters can be found here and there even today. They are very slow, in modern terms, but yield exceedingly sharp and precisely registered images. They are great for Mylar method printing.

Rotary offset presses are later designs. They are much more compact and usually turn at much higher speeds, but they still can produce perfect printing at very slow speeds, much to the production press-man's amazement. The arrangement of plate, blanket, and paper is mechanically different, but the printing process is identical. Simply gorgeous original prints of any number of colors, on any paper, can be run on these presses.

If you approach the operator of a commercial offset printing shop about making a fine-art lithographic print on his press, he will be taken aback by the tiny size of your projected run. He is used to thinking about many thousands of copies. And he will very likely not stock your special plates, supporting chemicals, and "weird" papers. So at first he won't know how to price the job for you. Nevertheless, if both of you are patient, you can arrive at an hourly charge, or, better, a per-color charge plus materials used, which will be fair to

you both. The actual quantities of plates and materials you need are not large. But when you have finished and gone, you will have left behind a whole series of new shop procedures and adaptations that the printers will find·useful in their future daily work. The experience and practical knowledge gained by Mylar offset will be absorbed by the whole shop. I have seen this happen a dozen times.

If you are hoping just to test proof a few sheets to get your feet wet, not that much time and expense are involved.

DIRECT PRINTING

Since stones do not bend, all stone lithography is flatbed, direct printing. Whether the press is operated by hand or machine power, the stone is kept damp by hand- or machine-dampening systems, ink is applied directly to the stone by some form of ink roller, and the paper is applied face down to the wet, inked stone, where the paper and stone together are subjected to tremendous pressure to force the paper down against the wet ink so that most of it will transfer into the pores and fibers of the paper.

Good stone printing requires a highly skilled craftsman-printer. All the many materials and chemicals are full of tricks, and they do not yield their best results to amateurs. That is the reason for The Great God Lithograph.

Mylar-method art is built around printing plates that were originally designed for the offset printing industry. Obviously, they will print beautifully on any offset equipment—if the printer knows his trade. However, these plates can also be printed direct on a hand press, in the same manner that a grease-drawn zinc or raw aluminum plate can be put on a stone-high block, rolled up by hand, and cranked through the press with the paper pressed face down against it.

To print Mylar-method positive plates by either system, certain techniques are different from those that are standard on either type of press. This chapter should be treated as a long addendum to texts which deal at length with standard offset or stone-direct printing. For practical reasons, offset will be dealt with first.

PRINTING ON OFFSET PRESSES

Offset printing is still based on the old principle of the mutual repulsion of grease-based inks and water, and the printing plate in an offset press exhibits this perfectly as you see it turning. The usual offset plates in use in the United States for many years have been negative-working; that is, the emulsion is burned under negative film copy containing all line material in solid areas and tiny dots—no washes. The light passes through these photo negatives where the actual image area-to-be is completely clear and the nonprinting areas are solid black. The plate emulsion is hardened by the UV radiation so that it can withstand the action of the developing solution. Therefore, the plate burns are long, almost the longer the better.

Decades ago, the old negative-working "deep-etch" plates, which had a deep surface granular structure capable of holding more ink and water, disappeared from the standard American print shop. Presses became ever faster. Since then, negative-working emulsions have customarily been applied to cheap aluminum plates with very little surface grain, hence very little capacity to carry water on the nonimage surface. As a result, thinner inks were manufactured to accommodate these smooth plates, and special papers came into use which held all of the ink up on the surface in order to get as much effect from its thin little image as possible. These coated stocks are a million miles from the kinds of absorbent, squeezable, art "blotter papers" best for fine-art printmaking.

Only recently have deeper-grained plates, both positive and negative, been coming back into use in this country, mainly due to the success of foreign printers in competing for major printing projects which should have been printed here. These projects were won by fine print houses in Holland, Germany,

France, and Japan because their quality was miles above what the industry here had settled for in the past. The manufacturers of the best of these new plates were in those same countries, and they began an intensive marketing campaign to sell their wares in this enormous American market, which dominates the world in volume, if not in quality.

These new deeper-grained plates are now all anodized aluminum, which resists becoming ink-attractive in the nonimage areas. They hold much more water in the deeper valleys and therefore can carry much more ink without clogging and filling-in. This has led to formulations of some very fine, densely pigmented inks with which one can, in concert with these plates, print extremely powerful, richly colored images even on the expensive, heavy, absorbent, luxurious papers artists use for fine-art print editions. Artists can now run offset on such papers as Arches Cover, 300-gram, all-rag, mold-made in France, and costing several dollars a sheet and more. Or the beautiful Somerset Satin, costing half again as much per sheet. Or even T.H. Saunders Watercolor paper.

I supervised the printing on this Saunders paper of an eighteen-color print on a one-color Heidelberg press, which I believe to be the loveliest printing of original handdrawn lithography I have ever seen. The print is titled "Shannandoah" and is a softly vignetted portrait of an Indian girl by the renowned painter of the American West, Don Crowley. It was his second original graphic, which should indicate that knowledgeable artists who are primarily painters can make superb prints, given the right tools and information. With "Shannandoah," offset printing, Mylar art, positive plates, exotic, absorbent, heavy paper, and a knowledgeable printer all came together to produce a piece of work of memorable value.

All these lovely, heavy papers can now be printed on beautifully, but there are thousands of offset printing companies who won't believe it until you lay down an example, run in many colors on a Harris or a Heidelberg just like theirs. One lifetime owner-operator of a multimillion-dollar printing house, examining sheets of continuous tone on Alympic Gold plates coming from his Heidelberg, said to me, "If I didn't see this happen, I'd never believe it. Never!"

As examples of what these new plates can do pass from hand to hand, and customer to customer, their use spreads rapidly in the United States.

HOW IT WORKS IN THE PRESSROOM

When your Mylar art plate goes into an offset press to print your few hundred copies, most of the time spent is for "make-ready," or preparation of the press. Positioning the plate in the press correctly, mixing the ink, setting up the paper guides in the feeder, and so on: all this will take quite a while, perhaps an hour or more. The equipment is designed for long, high-speed volume runs, and cannot be shortcut for a few hundred sheets. Grin and bear it.

However, you should insist that the press be slowed way down to a revolution count of less than three thousand and possibly as few as eighteen hundred impressions per hour. This is very slow for such equipment, and the pressman will become nervous at this alteration to his routine. He will have to adjust his dampeners to keep the plate properly just wet enough at this speed. There may be more mumblings, because he won't believe for a moment that you know what you are talking about. But if you do not get the press to run at this low speed so that after every few sheets one can be pulled for a quick inspection for spots, hickeys, and other flaws, your *very expensive* little pile of paper will have shot through that press in the blink of an eye, and any flaw will be on most or all of those dollars-per-copy sheets of paper. Better be nice but firm, until everyone understands the problem.

Once the pressman understands the special requirements of your project—and the costs of each sheet of your paper—his whole attitude will change. Odds are he will become helpful and rigorously inspect every few sheets for hickeys and other printing flaws so that the press can be stopped instantly if

anything shows up. As for you, don't be afraid to yell *Stop!* if you see a spot or flaw you know you will have to correct later by hand. Do it once on the press plate, or do it two hundred times when you curate your edition later.

You will be testing the printer's skill to the utmost. The plates may perform a little differently than he is used to. He may run up too much ink or mix it a bit too loose. Both will cause the plate to fill in or scum. All this can be cured by washing the plate down with Lithotene or a good ink solvent, etching it with a bit of fountain solution on a wet sponge, regumming it and buffing it down dry, washing the gum out with clear water, and starting all over again.

If the ink is too loose, stiffen it with about a #8 varnish and a copious quantity of rice starch. There isn't a chance in a hundred the printer has ever used rice starch, but it is a great ink modifier and, unlike magnesium carbonate (which he may have), it does not behave abrasively on the plate or cause any alkaline reaction in the emulsion. Rice starch can be ordered from major printing suppliers and found in some health food stores. What's left over, you can use for Chinese dumplings.

You should feel free to print on good printmaking papers in an offset press, provided they have enough structure and sizing not to become limp or come apart under the abuse of repeated passes through the press. I prefer quite heavy, surface-grained papers. But on any press I like to pass the papers through *three times* against a blank plate, in order to get them to do their inevitable stretching and deforming before I get image on them. It works, and is worth all the effort it takes.

Rotary One-Color Presses

Suppose your printer is going to use a rotary one-color offset press. Your plate has been positioned in the press. The paper has been stacked in the feeder, and a large quantity of at least several hundred sheets of used paper of similar size and thickness has been stacked on top of it to be used as run-up waste sheets, so that the plate can be fully dampened and inked, and thereby brought to normal printing balance.

Let's say you will be making a three-color edition on Arches paper, prestretched as described above. You have decided to run the main key darkest color first, to which you will later register the other two colors. Under your scrutiny and approval, the printer mixes up a big glob of ink on his slab, perhaps a black you asked to be warmed up a little with a bit of red, and made a little less than full strength with the addition of a dollop of "transparent" (a honeylike transparent ink) to dilute it.

The printer puts the ink up in the ink fountain and spreads it evenly. He will then start the press turning slowly and work the ink down into the inker system, but the plate will not be in contact. When he is satisfied that the inker system has a nice even film on the rollers, he will stop the press and, with a drenched sponge, will wash down the plate several times to dissolve and flush away all the gum coating protecting it. If it is a good shop, this sponge and water will be clean and kept clean all day.

While the plate is still quite wet, the press will be started slowly turning again, and the pressman will watch the plate begin to dry to a less shiny condition. At just the right moment, the pressman will engage the inking system but not the dampeners, and the ink will begin to appear on the image areas. After several more revolutions, the plate will appear fully inked, and a slight scum will begin to show in the bare areas. At this moment, the pressman should engage the dampeners, whereupon the scum should immediately disappear and the plate should be ready to print on the first waste paper sheets, gradually bringing the image up to its full strength.

If the pressman mistakenly drops the dampening system onto the plate surface too soon, the chemicals in the dampening solution will attack the image areas, weakening their receptivity to the ink. This can be cured on the press in most cases, if it has not gone too far, by cleaning the plate of ink with solvent, etching it with fountain solution, regumming thoroughly with an asphalt-based gum, such as Howson's Multigum or Petrogum, and buffing the gum down tight. Let it stand to dry for a few minutes, and then the plate should be washed down with clean water to remove the gum. While the plate is

wet, take a soft, clean pad and some of the ink from the fountain on it, and rub the image areas of the plate vigorously to prime them to receive ink again. The plate is then washed with water and sponge to clean it up, and the whole rollup process is begun again. This usually produces a perfectly good plate. If for some reason it doesn't, go right back into the platemaking room without further delay and make an identical plate, using your notes.

If the pressman mistakenly drops the dampening system onto the plate surface too late, when the first inking up of the plate is underway and after the plate has begun to run too dry so that the scumming has progressed rapidly to an awful-looking ragged covering of ink all over the plate, the dampeners will eventually more or less clean up the plate. But they will become contaminated themselves with all the excess ink they've been required to pick up. Printers hate that. They need to know this timing and do it correctly. Now that you know what is happening, you will have a good understanding of what you see.

If the press happens to be equipped with a special alcohol dampening system called a Dahlgren, there will be no contamination problem to the dampener. But the same care must be taken to keep the dampener from contact with the plate when first rolled up or after any plate cleaning that removes the ink, until the image has a solid protective coat of ink.

Waste sheets now pass through, building up the image, until one sheet of your good paper provides a first check copy and the press is shut down. Check this first copy long and thoroughly. Look especially for little spots and hickeys in the image and also in the margins. The Great God Lithograph, in a final twitch, continues to make these unaccountably difficult to spot in one's anxious first inspection, but they will look like beacons in the night when the edition is finished. This is the time to use the image remover, right on the press to clean all those flaws away. Also check the small, fine-line registration crosses you had drawn in the margins of your art. If they are positioned to fall outside the eventual trimmed edges of your edition paper, leave them in. If they could not be placed outside the trim line,

then run now a limited number of your edition sheets which will carry them. These sheets will be useful to check color register of each color later added. Then remove the crosses from the plate with image remover.

Check also to see if every part of your image is being properly inked. Check the position of your image on the paper. Measure the margins. All these things seem obvious, and they all go immediately out of your head under the pressure of all this unfamiliar machinery and surroundings. You may feel shy and embarrassed to bring up yet one more problem. But remember: secretly, everyone in the shop is absolutely fascinated with what you have brought in there.

You must be prepared to lose sheets as problems are found and corrected and reproofed, one by one. On a three-color edition of two hundred signed good sheets, you should expect the loss of at least an additional fifty sheets during the preparation and from the occasional glitches caught during the edition run. In planning for the edition, you should order enough edition paper to cover an additional 10 percent of the total number of sheets for every additional color of your image. You may not eventually spoil that much as your experience with this work grows, but unless you anticipate that many spoilage and proofing sheets, you may find you have fewer good sheets than your edition requires. If you have a publisher, he may not like that. And if you have pre-advertised your edition, you may find it embarrassing. You would then have an unhappy choice: either sign and number fewer copies than you need, or sign some copies that are less than perfect examples of your best work.

No printer can prevent the loss of sheets to flaws. If he's really good, he can help you minimize it, but it would be unfair to expect perfect runs. Watch what he must do to print for you, and you'll come to have respect for a complicated job. To help minimize the loss of sheets as much as possible, the press should be slowed down: this will permit you and the pressman, working as a team, to pull a sheet for quick inspection every few revolutions. It is extremely important that you assist in eyeballing

the sheets in this way. Check constantly for spots. It is *your* very costly paper you are protecting. If the pressman has not run work of this type frequently, he will not yet be fully attuned to the briefness of the run and the importance of every sheet to you, the artist. Each of those sheets is worth not just the cost of the paper, but the retail-gallery price of a copy of your edition. Once he grasps this, and accepts responsibility as a craftsman for the performance of his press on your work, he will be as eager as you for an instant shutdown when either of you spots a flaw.

Assuming your first color is editioned successfully, your second color can be run the same day. Since it may well be a lighter, transparent tint of some color the printer cannot precisely duplicate in his little PMS book of ink-mixing proportions, do not be afraid to go by your own experience as an artist/colorist. Printer's inks are really no different than oil paint, in that the pigments used to blend them are the same.

A really great way to judge the color and intensity of inks as they are mixed on the ink slab is to use scrap pieces of matte Mylar to test them against your print itself. Just touch your finger very lightly to the mixed ink, taking only a tiny amount (your finger is, needless to say, clean). Dab-dab-dab it onto the matte surface in a little even patch which is just short of sticky. Hold that down flat, ink side up, against the concerned area of your print. What you will see will be very close to what that ink will give you on the press.

Your printer will most likely never have seen this little trick, which works a whole heck of a lot better than any other quick-test method I have ever seen.

If you are working with a light transparent tint that will, nevertheless, have a lot of ink coverage on the plate, you may well find you get the best possible result by using as an ink base a very high quality dull overprint varnish, such as the Superior Ink Company's Dull Overprint Varnish #W-2278. The print shop's usual "transparent" or "white" base, which is neither, is usually far too yellow for our purposes in making pale tints. It will warm up pale

blue tints into greens, and pale violets into grays, and so on.

Pale tints with much coverage of ink on the sheet are central to a printmaker's coloring technique. They are often mixed of 98 percent tint base and 2 percent color ink, or even less. Therefore, the on-press performance qualities of the tint base are extremely important, and not to be compromised because the printer doesn't want to order in something different. I use the Superior Dull Overprint Varnish for this purpose because I have found that it goes down on fine-art papers beautifully, remains color-neutral in tint mixing, dries quickly with no gloss, and behaves very well on the plate. All this is far from true of the cheap transparent "whites" used in many shops. Since your kind of job may have a great deal of such a base on the sheet if you are printing several colors, what you use really matters.

Most larger ink companies now make a line of long-life so-called fade-proof inks. They are none of them fade-proof as yet, but these more expensive inks do resist fading much more effectively than ordinary printer's inks. Such inks from the Superior Ink Company are truly superior. Hanco inks, made by the Handschy Chemical Company, are widely used; the special line they manufacture compounded of the standard artist's pigments, especially all the earth colors, is extremely useful to the artist/printmaker. These can be ordered from the Rembrandt Graphics Arts Company of Rosemont, New Jersey.

Especially useful is Hanco's Special Opaque White, a super-pigmented opaque white which bears about as much resemblance to the thin white gruel on the average printer's shelf as does a Ferrari to a roller skate. In fact, if you do much of this work you may find that printing with opaque inks built on this dense white base is a fabulous technique. Think of running all your colors chiaroscuro on black Arches paper and seeing them really sing. I've had the pleasure of doing that many times.

A final comment about inks. Some manufacturers put out a line of pure trash—thin, weak and fade-easy. Some printers use this stuff because they have no particular interest or pride in the ad brochures,

promo pieces, throwaways, product labels, and the like that they are called upon to print. Ask them to order at least a few good inks for your main colors, especially pale tints that could fade. Ten percent fade of a strong red may not be crucial, but 10 percent fade of a 2 percent pink tint is *gone*.

REGISTERING THE NEXT COLOR

Your second color is in the press, and the first good sheet comes through. Take the printer's loupe that you have now bought and carry everywhere in your pocket like a pro, and use it to inspect the very fine-line register crosses which remain your first and most reliable guide for checking the initial registration of each new color plate. A certain number of your first color sheets will have the crosses, before you removed them for the clean edition run; that is, unless the crosses are in paper that will trim off later, in which case they remain throughout. But just in case you made an error in register-cross or pin placement, find several little checkpoints in the art itself where the two colors just touch each other or in some way give you a precise reference. The work is the work, and it is the image register, not the crosses, that will make or break you in the end.

If you see a problem, ask the printer to make the adjustment. Proof another sheet and check. Be pleasant but firm and insist that you get the best possible register, as well as greatest possible plate cleanliness, before you give the okay for the edition run to begin. Again, you will feel the unspoken and undefined pressure to get on with it. Resist this until you are satisfied. Only that way will you ever get a print for which you, the printer, and the shop can feel real pride. And only thus can you learn.

You can see that I am harping on this, because I have felt this pressure and have seen it overcome the good judgment of many another artist who had not been forewarned. Only the artist's aesthetic judgment should be making any decision about his print. It is only the artist's name which will be signed to the result, and everyone involved should remember that. If you are patient with the printer and *if you know what you are looking for,* you, the pressman, and the shop's boss will all burst with pride at this very unusual job done so beautifully in their shop. They'll run all over, showing a copy of your print as an example of their work.

Your third color repeats the procedure of the second, and you have done it!

You will have much or little curating of your edition—razor-scraping of spots from the margins, correcting tiny color flaws with colored pencils or washes of the inks from the run diluted with odorless thinner, and so on—depending on how vigilant you were previously in insisting on finding and correcting all these little annoyances on the press. I emphasize it again, because I may be saving you thousands of working hours in your career: if you fix it once on the press, you won't have to fix it two hundred times on the sheets of your edition.

If you had set out to make a twenty-color edition, nothing would be different in the description of the work involved except for the cost and the order in which the colors would be printed. If you ever decide to run many colors on a print, you cannot run them all over the top of the main dark color, as with three colors. The areas of overprinting would erratically affect the main dark color where it ran beneath the overprinting ones.

If your many-colored image depends on a dark color for its definition, plan your color printing sequence so that you first run a hundred sheets with the main dark color and its register crosses on them, and then remove that plate and save it under gum. Use the hundred sheets to position and set the colors, one by one.

Put the next plate, probably a large and light color area, in the press, ink and proof it against a few of the hundred sheets until it's okayed, and then make your edition run. Now you have one light color, seemingly undefined, on the whole edition. Set up the next color, choosing it by deciding however much it relates to the one just run. And so on, until

you have many colors down on the sheet. Each of them has been individually related, with great care, to the position of the first image on the hundred sheets and to all the other accumulating colors. You may want to get out your Mylar drawings to refresh your mind about where and how you intend everything to appear. If you are following a color sketch or painting, there is much to guide you as you go. If you are rigorous about register-checking each of the colors and if the press is a reasonably well-adjusted piece of machinery, you have nothing to worry about at all. And remember, you can always make a "fix drawing" at the end to deal exactly with any little error you just can't stand.

Working in this way, you will see your image building up, color by color, looking more and more complete, as the colors multiply and enhance each other. It's often a very pretty sight, even unfinished. If you plan to run any main dark color last, or almost last, you will have allowed yourself the option of adjusting the color you choose for it so that it best complements all that has already come into existence. That is a very valuable option. Often you will find yourself changing your mind, even at the last, and deciding to run it less intensely or with areas diminished by Image Reducer to give visual perspective, or even to remove some parts as unneeded. It is always amazing to watch this last run pull the whole thing together.

DOUBLE IMPRESSIONS

If you are on a good press that is holding good register of your colors, there is no reason not to run any color, including your most subtle and detailed drawings, two times through the press dot over dot.

Your paper has been prestretched. If you print twice in rapid succession, any small changes in shop temperature and humidity will not have time to change the dimensions of the paper and do not affect the plate at all. You cannot expect to do this

if you wait a few hours or longer, for all paper comes and goes to a slight degree unless the shop is superbly temperature and humidity controlled. Most are not.

On consecutive large, complex editions of mine—"Willis Bliss, Vermonter," "Lucky Lady," "The Woodsman," and "The Gazebo"—the main key plates, all very extensive drawings covering large areas and with a great deal of delicate toning, were run twice in rapid succession. They are all superb printing images of exquisite tonal range. By planning in advance to do this, I was able to get more ink coverage and visual contrast against the paper than the plate could have taken in one heavy pass. Also, the great image strength was achieved with no risk of filling in the deeper, richer pencil tones which give life to the shadows of beautiful drawing. Filling in is the stone printmaker's curse, and The Great God Lithograph's most awful revenge, since it can often ruin a stone irretrievably. But, by double-hitting I achieved a powerful image safely, with the deeper dense drawing areas still open and clean looking. No mean feat. The pressman, new to this kind of work but old in the business, nearly passed away from nerves, but he is very proud of his results. I signed a copy of each edition to him personally, as is customary.

All of this description of rotary-press printing applies to flatbed offset printing as well, except for the speed of the printing process. Flatbed presses are very much slower and are often fed one sheet at a time. If you try double-hitting any color on these presses, do it on small batches at a time to prevent paper changes between hits.

PRINTING ON DIRECT PRESSES

From 1975 up to the writing of this book in 1982, almost one thousand editions of Mylar prints have passed through the beds of the two big direct-printing, stone-type, powered presses at the American Atelier in New York. And other ateliers with similar equip-

ment have added greatly to that total. These editions used plates burned, processed, inked, and printed just as described above, except that the presses, being direct-printing, press the paper directly against the inked plate and not against an intervening rubber blanket.

The American Atelier's two lovely old, growling Marinoni-Voisin powered stone presses are true antiques so massively constructed that they probably could run literally for several lifetimes more. They printed thousands of stones in France for many decades and many thousands more after being brought to Bank Street in New York in 1967.

But since 1975, they have been devoted almost exclusively to Mylar printing. Upon seeing the new Mylar work in progress, hundreds of artists who came to the American Atelier for professional printing of their work chose to use it.

If you are able and equipped to print stones or have access to a stone press and printer, there are not too many adjustments that must be made to what has already been described in order to print Mylar-method lithography. By using a stone-high block as a base, the direct press can print grease-drawn zinc and raw aluminum plates and it can also print Mylar-made plates, providing the dampening methods are altered to match the capacity of the plate to hold the moisture necessary to permit clean and unspotted inking.

I early found several characteristics of these positive plates that called for new techniques. If you are familiar with stone hand printing, you know the surface of the stone is usually sponged by hand prior to rolling the ink roller across the image. The Mylar plates hold a lot of water, but being anodized they do not hold an adsorbed gum base in the nonimage areas; the dampness on the surface is held in a different way. It is virtually impossible, no matter how much care is taken, to sponge-dampen a Mylar plate with a large solid area of image without leaving water dots in the image which show up in the inking and in the impression. If the sponge is wrung dry enough to avoid the beads, the ink will scum the clean areas. No amount of ink modification

or sponge-water modification solves this difficulty. I finally saw that the problem is in the porous, irregular structure of the sponge. After some thought and lots of experimentation with cloth dampener covers for smaller rollers, I finally developed the "rocker" you will see diagrammed and illustrated on page 33. This rocker is of lightweight construction, covered with layers of porous, absorbent materials: thick sponge inside covered with layers of pure cotton felt, and pure cotton high-count percale sheeting stretched tight over all.

This rocker is actually a big partial section of a huge cylindrical roller. In printing, it is lightly and evenly dampened throughout by being sprayed repeatedly with clear water in a trigger-action spray bottle. I keep a bucket of dampening solution at hand with a mixture of two ounces of commercial offset fountain solution to two gallons of water, and a sponge. If I have to use this occasionally to keep the plate clean, the rocker deals with any beads and streaks.

When the plate is sponged quite liberally—almost puddled—the dampening rocker is used to absorb and even out the moisture by rocking it back and forth a number of times. Because of its construction, you can instantly increase the degree of wetness by bearing down on the ends just a little, but mostly its own weight rocking back and forth is perfect for evening out the moisture balance on the plate prior to rollup.

The areas of the rocker out near its ends are not effective, so the working area is perhaps two-thirds of its length and almost all of its width. To be able to handle different sizes of image, I built two versions. Either one can easily be handled in the press area by a lone printer. If you encounter this dampening problem, you will be glad you built one.

Incidentally, while I am recharging the ink roller between impressions, I often put the rocker down inverted over the image on the plate. It slows evaporation and keeps the plate quite damp long enough for me to develop an easy rhythm in the printing. When it is not in use, I hang the rocker on two hooks within reach. Spraying the rocker lightly every

couple of impressions keeps it evenly damp and the rhythm going.

ACHIEVING REAL REGISTRY ON A HAND PRESS

Some years ago, I had a local machine shop make me a pin-register bar, like the one shown in figures 31 and 32, on page 62, to fit the Duralumin plate block on my Charles Brand 30″ × 50″ hand press. The two end blocks are adjustable back and forth on either side and the bar itself can be adjusted from side to side by fine-thread vernier screws. To its flat steel bar are spring-clipped a couple of low-profile register pins that have been modified to fit. They can be emplaced wherever needed.

I found several ways to use this gadget. The last, and best, controls both plate and paper.

Let us say I have made a nice Mylar drawing of medium size. I choose an elegant paper to run it on—Lana, for example, a soft and satiny off-white sheet. I first pass all my sheets through the press under very heavy pressure against the shiny smooth back of a discarded plate, which is much less gripping and abrasive than the grained side. I pass them through three times to get the stretch out. Then I place my Mylar drawing face up on one of the sheets, positioning it on the printing side as disclosed by the watermark and setting it up so that the margins are all allowed for. I tape the edge of the Mylar toward that edge of the paper which will be closest to the press scraper bar during printing. I allow a very generous margin on that edge so that I will be trimming off at least six inches of excess beyond the print margin when the edition is finally complete. I reinforce that edge of the paper (which may not lie at the top of my image) with a strip of Scotch white Artist's Tape #285 on both front and back.

I punch this edge of all the sheets to be used for the edition in my homemade punch machine. Punching each hole by hand, in accurate position on all these sheets, is certainly possible using the metal-plate strip punch guide as previously described,

but is a far more tedious procedure than using a simply constructed punch machine similar to the two shown in the photographs.

These pin register holes in the tape-reinforced edition paper will now have good durability and resistance to distortion, far beyond that of the paper alone.

In safe light, I center a new plate in the punch machine and punch it. To burn the image, I put the plate in my vacuum frame and place my Mylar drawing face down on the plate, registering the two with low-profile pins. The paper strip on the edge will leave an unwanted solid image area that is quite easy to eliminate by removing the Mylar after the burn and, shielding the actual image area with scraps of Rubylith, or by use of a Mylar image mask as previously described, burning again to get rid of the paper's ghost. I set aside the Mylar-paper assembly and develop the plate as usual.

I use a plate large enough to permit easy use of whatever size hand ink roller will roll over the whole image area without a repeat on the roller surface. This means that the roller must be some few inches longer than the dimension of my image, which lies along the long axis of my press, and must have a circumference some inches greater than the other dimension of the image. Secondly, the ink roller's length must be taken into account when the plate is chosen and trimmed for the press, to ensure tha' the roller does not contact the plate edge, or the tape that holds it down. If the plate size chosen extends beyond the edges of the block in the press bed, I remove the plate to another table, scribe it with a blade, and with a few gentle bends remove the excess. Also scribe a line one inch in from the edge along the punched gripper, but do not bend off.

All the prestretched, tape-reinforced, and punched edition paper is now stacked nearby in small piles, since the added thickness of the tape strips makes one end of the sheets quite bulky. Each sheet will go face down on the plate for printing, in perfect relation to the image on the plate.

Place the plate on the pins of the press pin bar, and center the image by sliding the pins along the

bar. When satisfied with the plate's printing position, tape the plate at its foot, opposite the pin bar, and along both side edges with two-inch plastic heavy-duty shipping tape. Place the Mylar art sheet with the punched paper addition, which you used for plating, on the pins face down against the plate. There should be a perfect register of images, under the magnification of the loupe.

If for some reason there is a misalignment, it means you made an error in the platemaking process. If the error is slight, and would not noticeably alter the position of the image in the margins of the paper, go ahead and print as is. If the error is larger, lift the plate from the pins, being careful not to pull up the tape which holds it in position, and gently bend the pin-punched edge along the scribe mark until it is separated. Tape that edge down also.

The plate will now be free of the pin bar, so that vernier screw adjustment of the pin bar, with the Mylar image sheet on the pins face down, will cause the Mylar image to come into perfect register with that on the plate. Proceed to print.

In actual fact, use of the pin bar is so accurate that I have repeatedly double-hit impressions on the hand press. If you do this one after the other on the sheet, the moisture of the first impression has no time to cause the paper to expand. If the paper has been well prestretched, the printing is lovely.

The same registration system is used on additional colors. If any noticeable paper stretch or shrinkage has taken place, use of the Mylar-paper guide on the pins will disclose whatever adjustment is necessary.

The entire edition of my first plate-glass edition, "Summer Song," was printed in this way with one interesting exception. I used Lana, which was deckled on all four sides, but I achieved very exact color register in the following way:

I set up the pin registry by adding separate strips of stiff paper adhered beneath the top one inch of each Lana sheet by means of a light, pressure-sensitive adhesion film called Fusion 4000, which can be procured from any picture framer or frame-supply distributor. These extra strips projected several inches beyond the Lana's beautiful deckle edge. I punched that extra edge on all the sheets, and the edition printed in perfect register in three colors. Once the edition was complete, the paper strips were easily removed, and all traces of the surface adhesive went with them.

Inks on a Hand Press

Mixing inks for these plates is the same as for any lithographic printing, except that stone printers must remember that the inks must be stiffer and less greasy than for printing grease-based stone images, and that strongly surface-patterned ink rollers may leave their pattern on solid areas. Double hitting of colors can be routine because of the precision with which the sheets are positioned, yielding exceedingly rich, luminous color printing. I have often double-hit key drawings as well, getting dot for dot success on about three out of four sheets in one hundred tries. I don't consider that perfected, by any means, but *on a hand press*—something to think about.

PLATE IMAGE LIFE

During the life of a plate on the hand press, it lies exposed to whatever light bathes the press. As you may remember, daylight, incandescent, and fluorescent bulbs are all sources of UV radiation, which can cause the plate emulsion to become susceptible to any alkaline substance. Many printing papers are heavily buffered with alkaline compounds to protect them from the eventual degradation of the fibers, which can be caused by acidity picked up in the processing of the paper itself or absorbed from our polluted atmosphere.

So, in these papers, which in direct printing come into high-pressure contact with the damp printing plate, you have another of those conflicting situations. Acidity and alkalinity are simultaneously both valuable and destructive.

There are three possible solutions. The first is to use fine all-rag papers with as little buffering as

possible. The second is to bake the plate just after its development and cleanup. This is accomplished, on Howson Golds, by bathing the plate with Howson's Thermotect solution and hanging it free in a hot-air oven for a few minutes at 450 degrees. All volatile components of the polymer coating are released and evaporate away, leaving the image a virtual ceramic on the plate, impervious to just about everything. This is certainly a full and final solution to the problem—and to any and all printing problems—but it requires access to a shop that has or can locate an oven—even a pizza oven—large enough for this purpose.

The third is to block virtually all UV light from getting at those plates except during the burns. This you can do by interposing a very effective UV-absorbent clear sheet of Plexiglas between all window daylight or artificial light sources and the press surface. Such Plexiglas is made in several types and nationally distributed to plastics supply houses by Rohm and Haas, Inc. One type, nearly 100 percent effective, has a slight yellowish cast. Another has almost no tint and stops about 90 percent of all UV radiation. Not bad.

In my own shop, I have built rather a nice-looking set of shields of wood and the colorless Plexiglas over the fluorescent fixtures in the press area.

When I first started printing with Howson plates on my Brand press, my plate images often weakened sooner than expected. I thought it might be plate printing chemistry, but it all checked out slightly acidic. I then suspected abrasion caused by rough papers being rammed against the plate under great pressures. It was that in a way, but I now believe the alkaline buffers and sizings in the papers were the reason. With the arrival of the UV shields, the problem evaporated.

With these many techniques and with this large family of new printmaking materials, lovely original lithographs can be made by either offset or direct printing. I suspect The Great God Lithograph will not be too happy at the appearance of this book about Mylar-method lithography. Mylar printmakers pay him little mind these days.

I believe all the information necessary to equip any artist who wants to make Mylar-method prints of professional quality is included in this book. But however you make your prints, I hope you have as much fun and creative excitement with them as I have had with mine.

INDEX